A little
Levity
never hurts.

Storydweller Comics
by Jonathan Vreeland

ISBN: 978-1-954614-45-1 (hard cover)

Edited by: Amy Ashby

Published by WARREN Publishing
Charlotte, NC
www.warrenpublishing.net
Printed in the United States

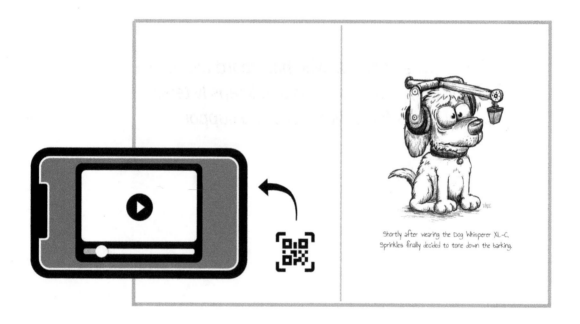

Shortly after wearing the Dog Whisperer XL-C, Sprinkles finally decided to tone down the barking.

Next to each comic, you will find a QR code that you can scan with your phone's camera. Hold your camera over the QR code and a website will pop up. Please click on that website address for a quick time lapse animation of the comic's creation.

There's something special about a sketch paired with a caption, a mini story compressed into a single panel. Sometimes the joke hits right away. Sometimes you need to take a moment or two. Either way, you get to take the time to enjoy each and every comic. Now I hate to brag, but I've taken Storydweller comics to a whole new level. Seconds could turn into minutes, days into months, possibly even years. You might ask, "How is this possible?" You see, my two sons have quite literally grown up with Storydweller comics. When I start a new concept, I'll ask for feedback. As you may imagine, this generates some confused looks and a series of questions:

"Dad, why is the dog's Halloween costume a fire hydrant?"
"Dad, why is the flower grounded?"
"Dad, why is the tree so upset?"
"Dad, why don't you add some color?"

As my kids have gotten older, I've started to hear "Oh, I get it. I get this one!" or "Hey, Dad, that's actually funny!" It took a few years, but my toughest critics are starting to come around. And by the way, here's their feedback on this introduction:

"Just say it's about jokes."
Emerson, age 6
Favorite comic: Smokin' Hot

"I have no idea what to say. You just like making comics."
Oliver, age 8
Favorite comic: Spring is in the Air

The collection of comics before you has brought a ton of levity into my home. I hope it will do the same for you.

Blank Face

"Why the blank look on your face?"

Indecision

"Just let go!"

Elevator

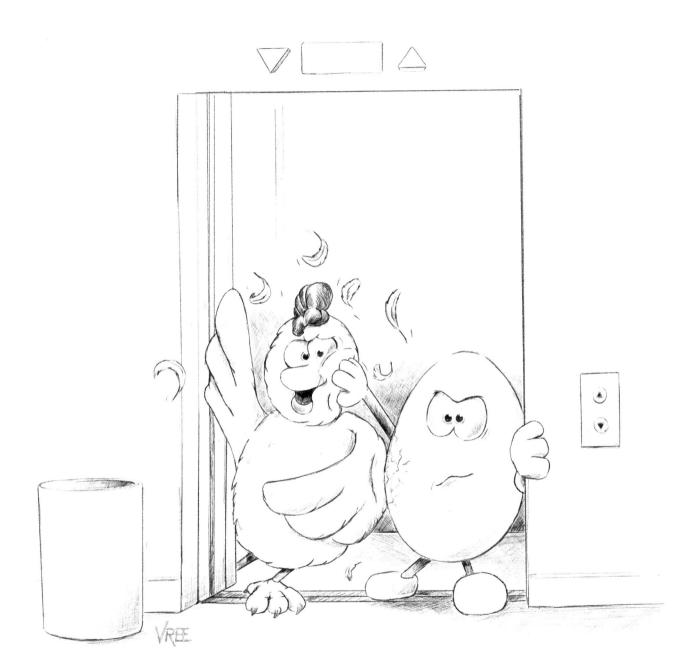

Lag Time

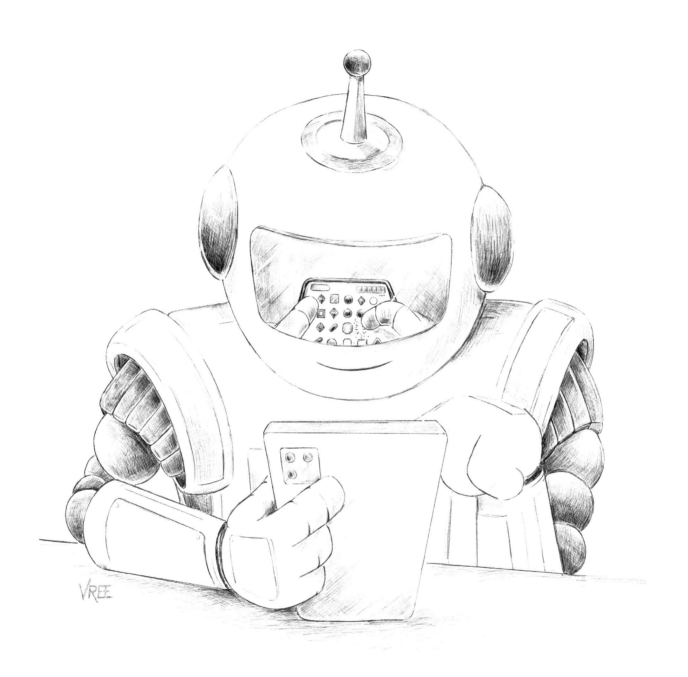

Tom's lag time increased dramatically.

Patent Pending

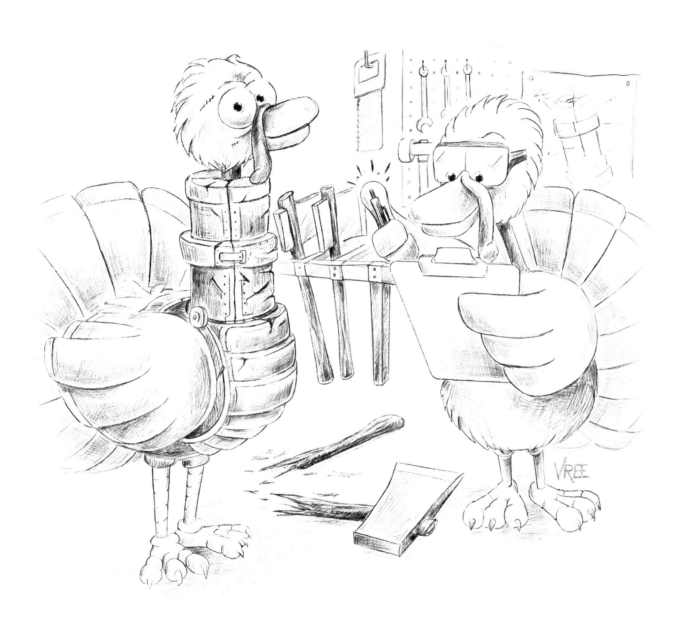

Patent Pending

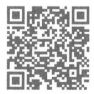

Spare-ritzen

Spare-ritzen: The most unknown reindeer of them all.

Family Portrait

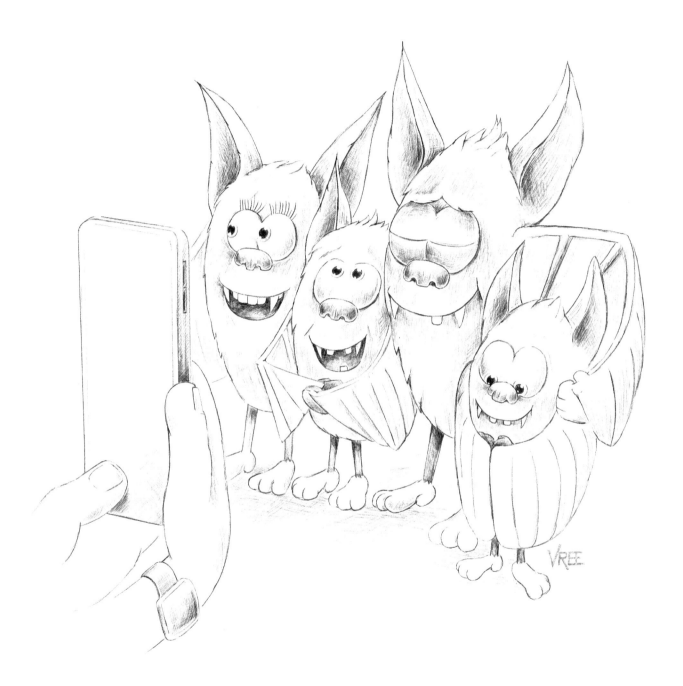

"Let's try one more, but this time look toward the sound of my voice."

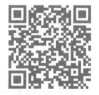

Balanced Diet

"Now Jr. ... you have to eat the WHOLE page, the vegetables too."

First Flight

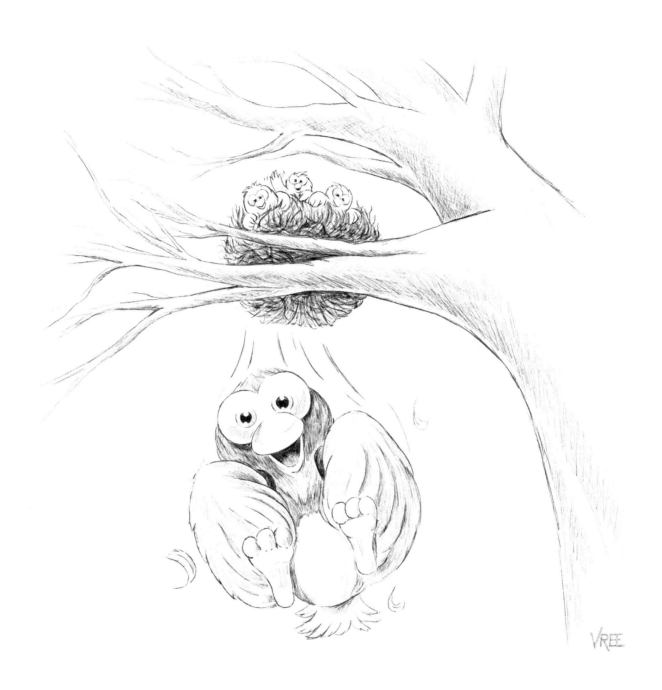

"Cannonball!"

Easter Egg Hunt

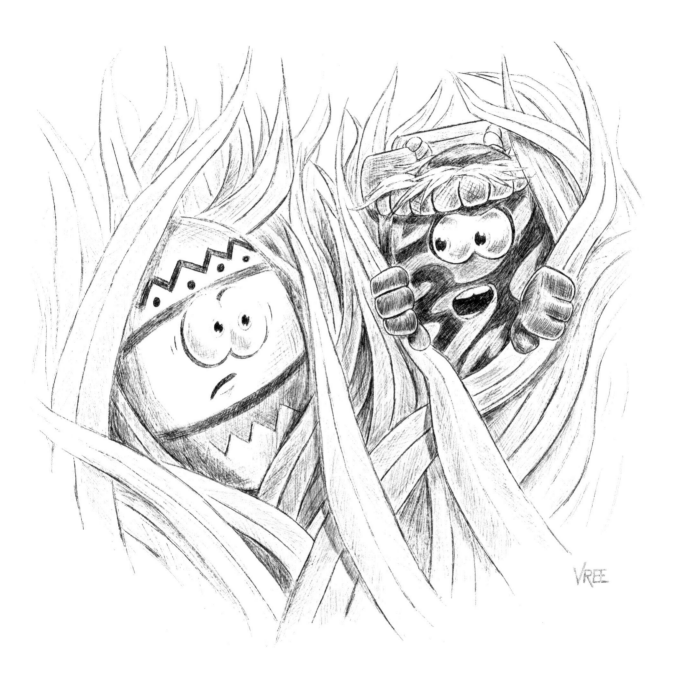

"Come with me if you want to live."

Four Wheelin'

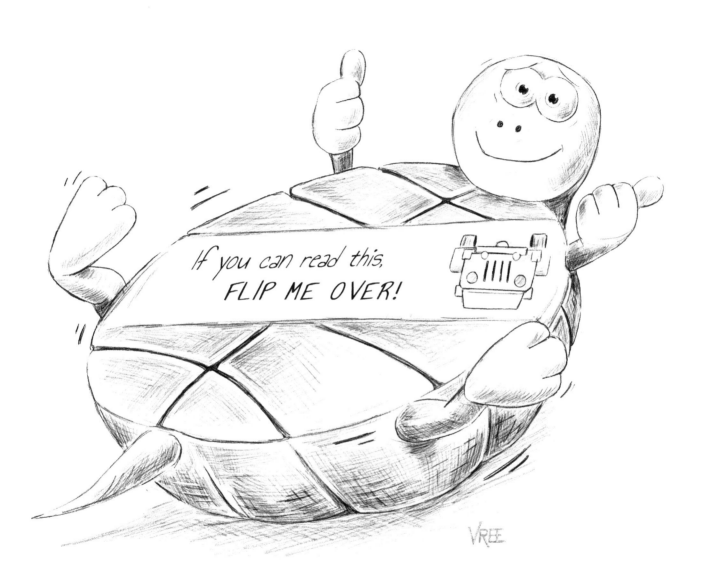

Four Wheelin'

Basset Fish

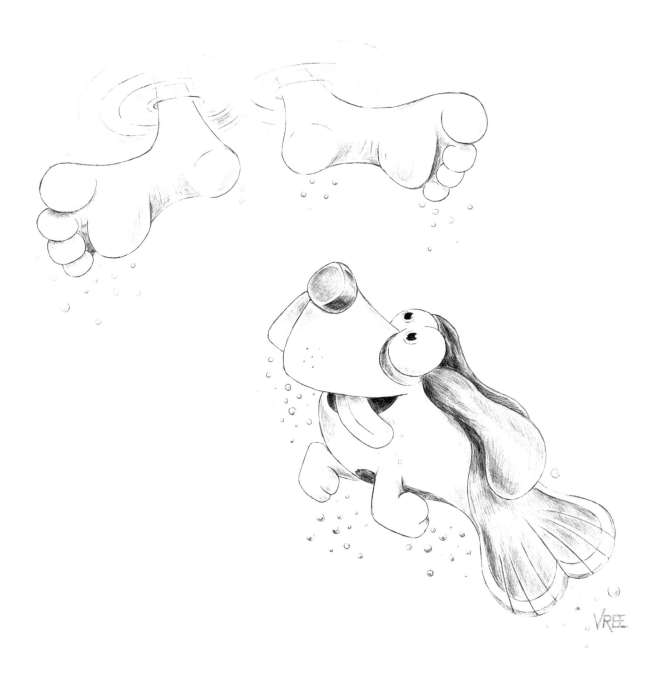

The mystery of Licking Lake was solved
with the discovery of the Basset Fish.

Diversification

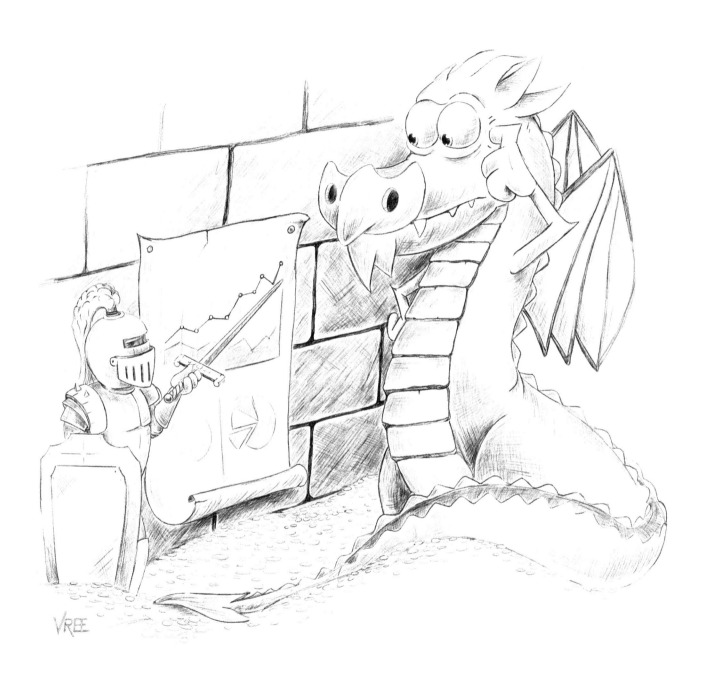

"Obviously, you're long on gold.
Ever think about diversifying into Bitcoin?"

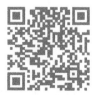

Not So Great Deals in History

"So let me get this straight. They'll stop attacking
us and we get the cool horse? ... Awesome!"

Tree Hat

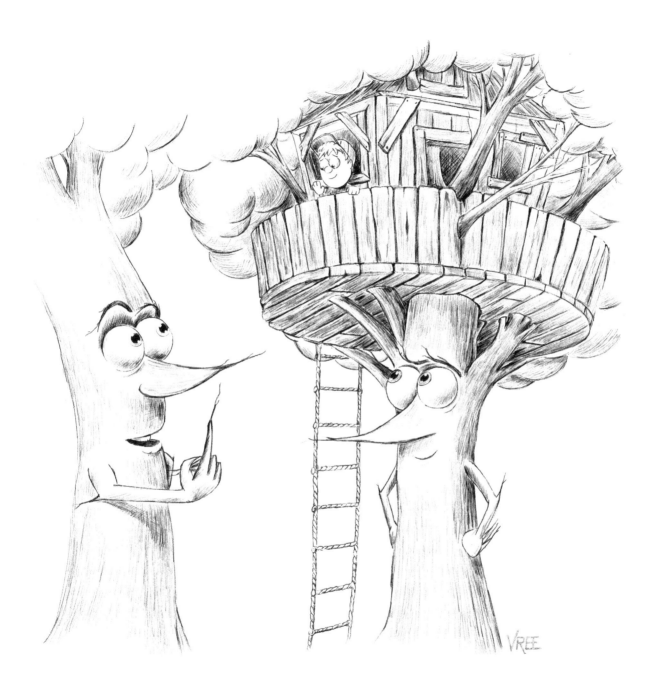

"Did you know there's a kid in your new hat?"

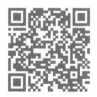
New Mom

Mom prepared us for our inaugural swim.

Vantage Point

"Oh, wow ... wait until you see this view!"

Waiting

"She said she would be ready in five minutes—
that was over forty-five minutes ago."

Heartburn

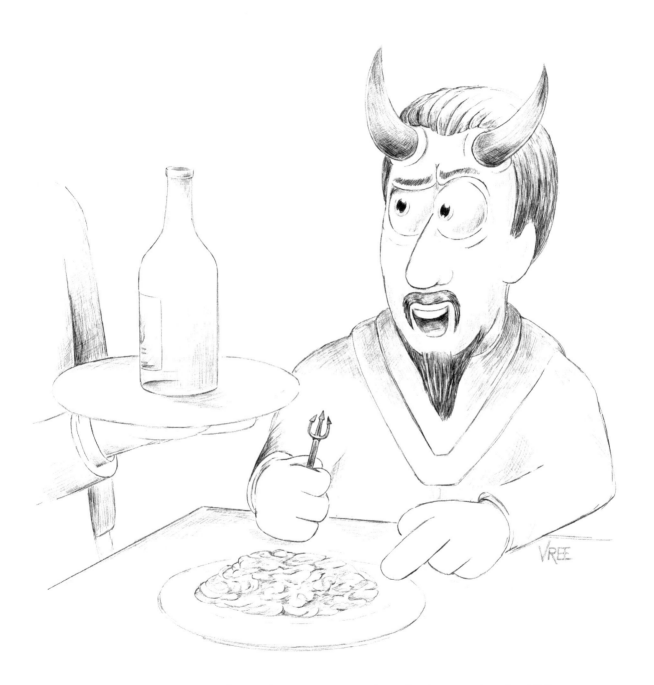

"When you say hot, do you mean hot hot or spicy hot?"

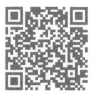

Carbon Footprint

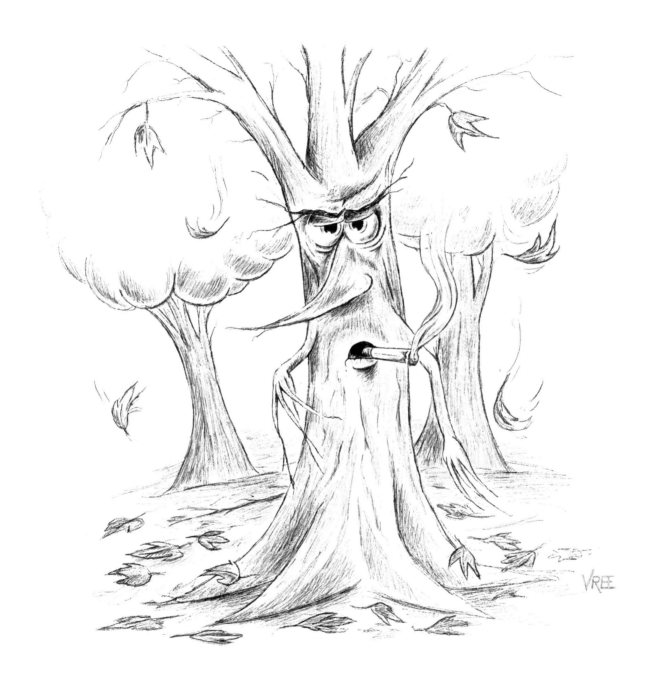

Parker's carbon footprint was officially null.

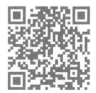

Tree Tattoo

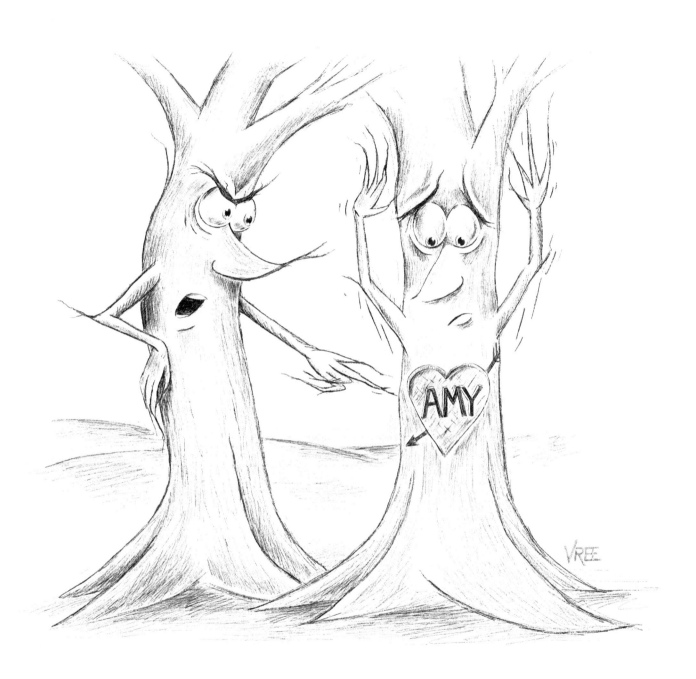

"What do you mean you don't know Amy?!"

Golden Blazer

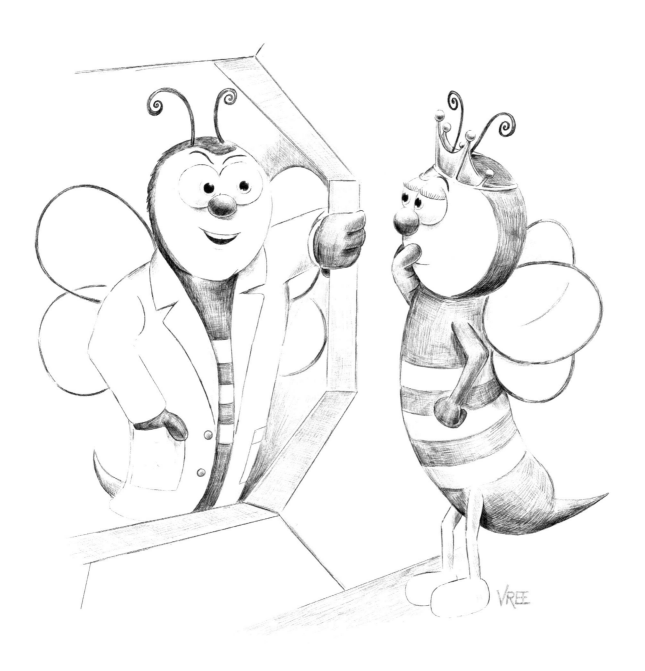

"It's not a yellow jacket, Mom, it's a gold blazer.
All the drones are wearing them."

Sock Cop

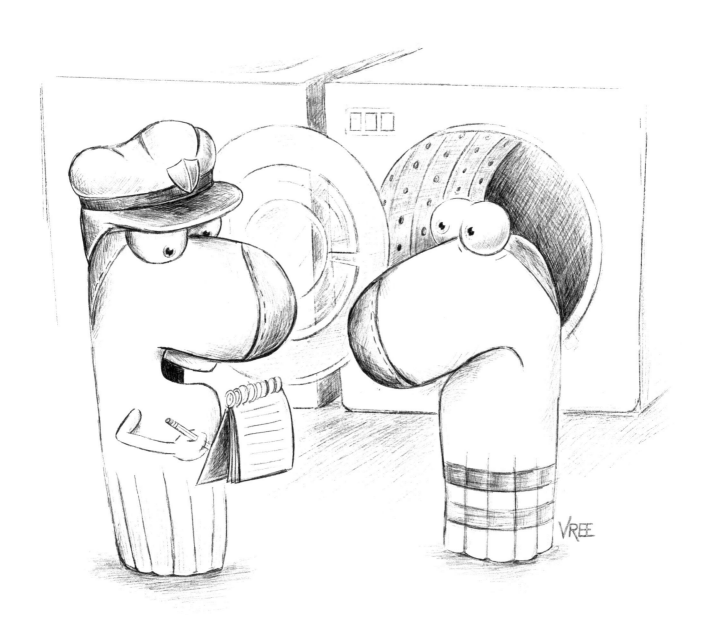

"Just to clarify—you and your partner entered the dryer.
A heated struggle ensued. And now he's missing?"

Coin Toss

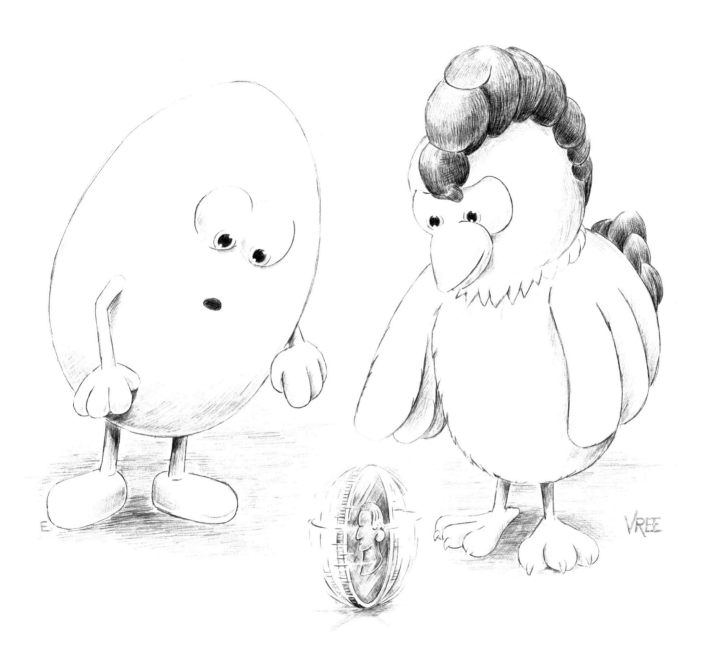

Swallow Your Pride

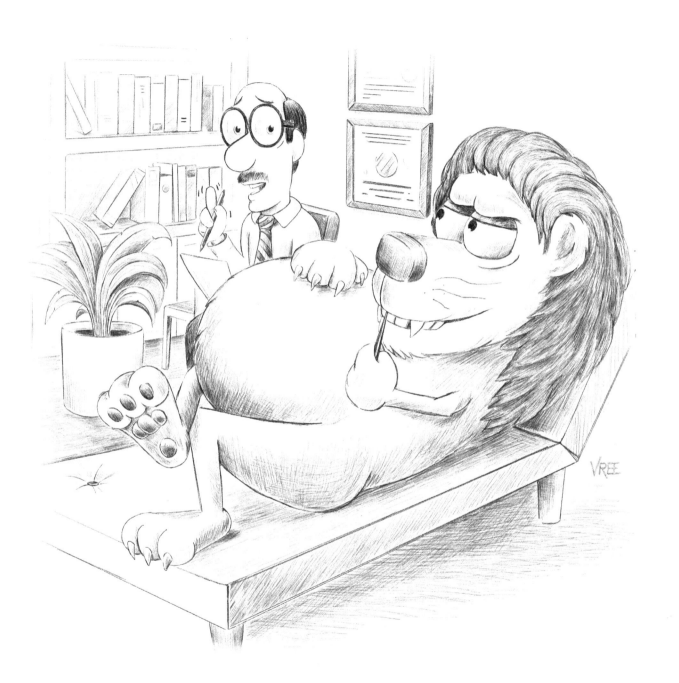

"That's not what I meant when I said swallow your pride!"

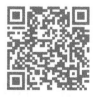

Death Roll

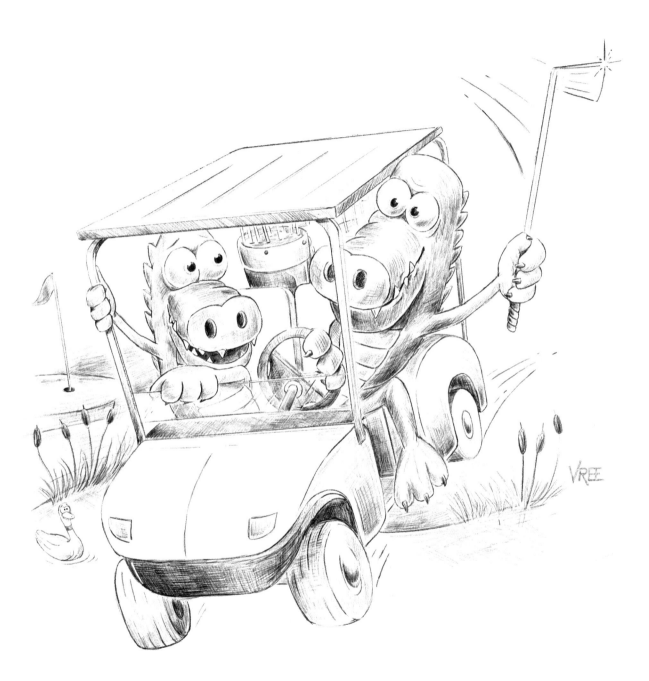

With the diminishing wetlands, the evolution
of the death roll was much more effective.

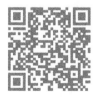

Short Nose Alligator

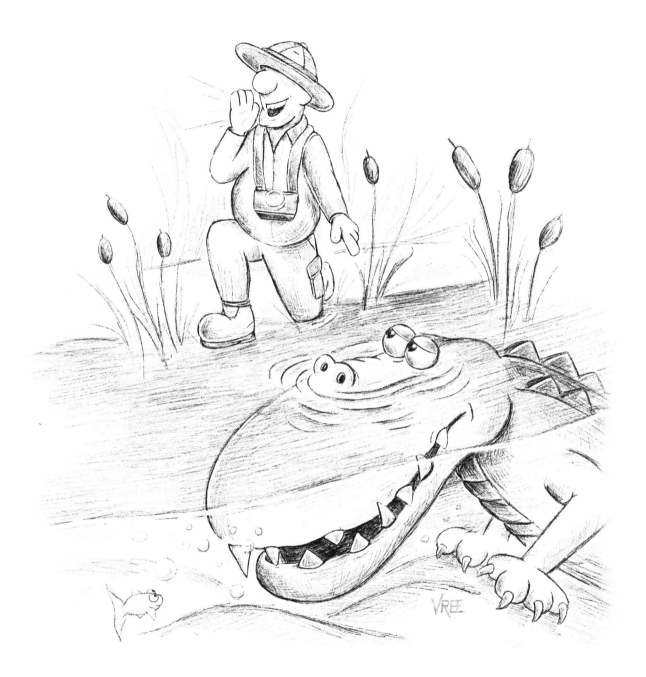

"Hey, honey come look at this baby alligator!
It's coming right up to me ... sooo cute!"

Caught Red Handed

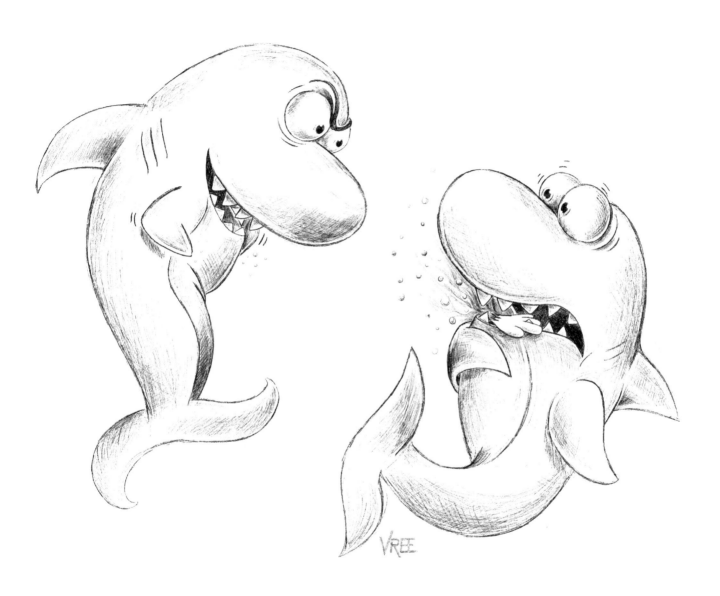

"Thought you said you weren't going to the beach today?"

Possum Surprise Party

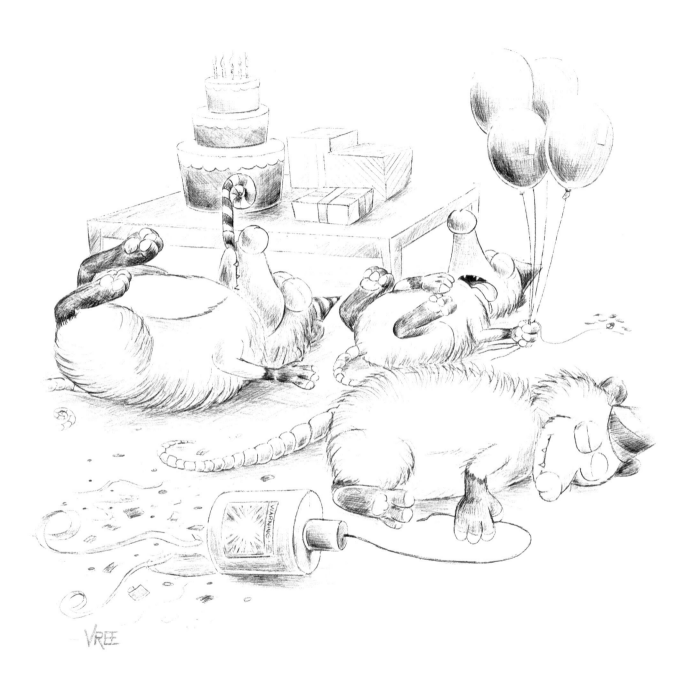

Possum Surprise Party

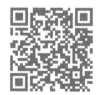

The Comb Over

The Comb Over

Jump Start

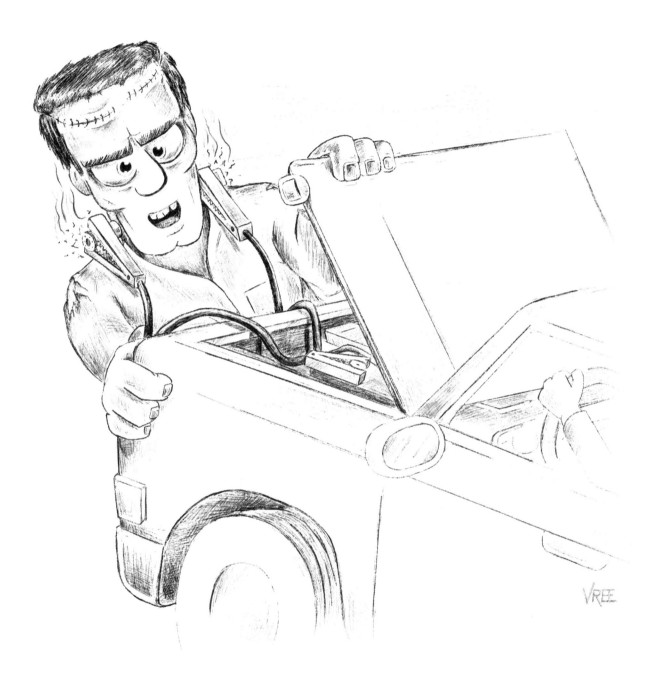

"This time, try giving it some gas."

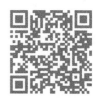

Power Down

"The captain has requested that
passengers turn off ALL electronic devices."

Love is in the Air

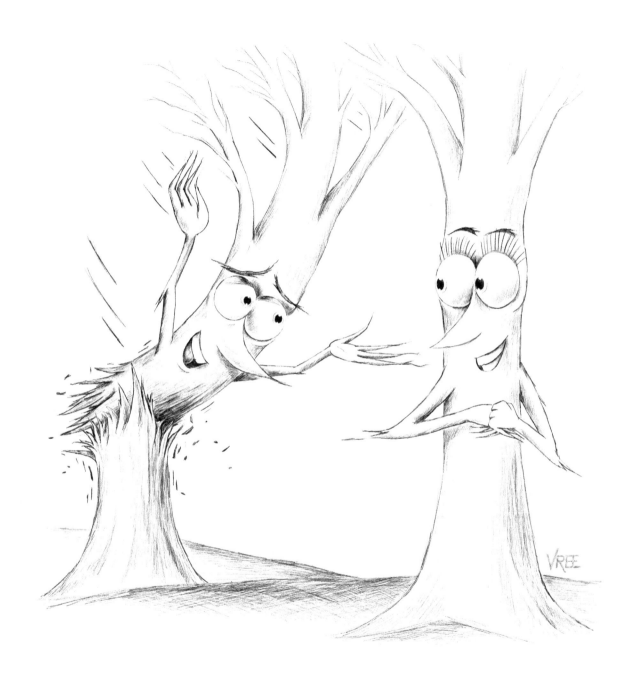

"Hey, babe—I thinking I'm falling for you!"

Smokin' Hot

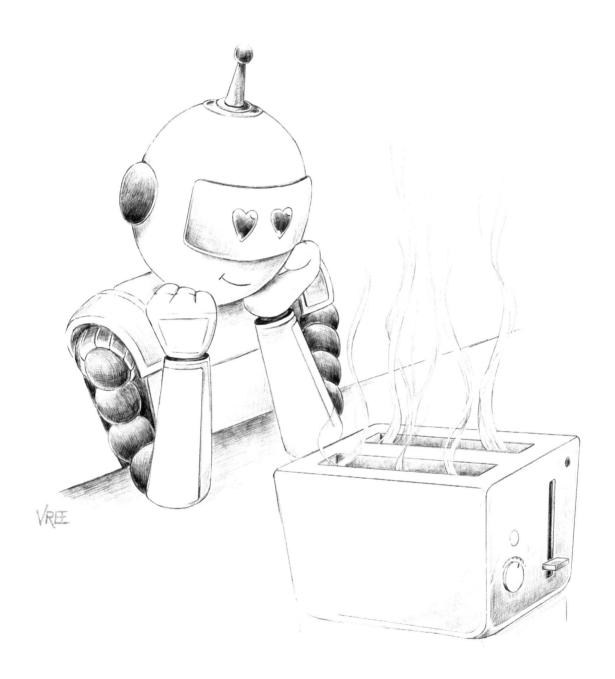

Tom always thought the toaster was smokin' hot.

Inorganic

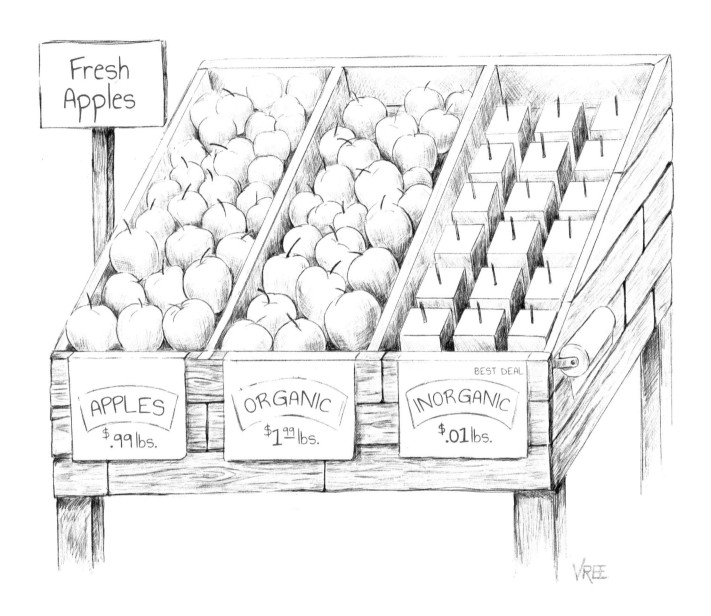

The all new inorganic section is a huge money saver.

The Cavity

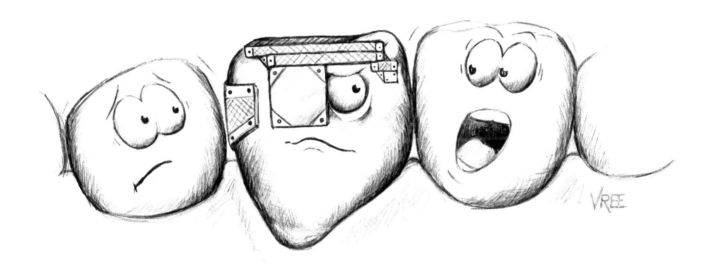

The Cavity

The Spin-off

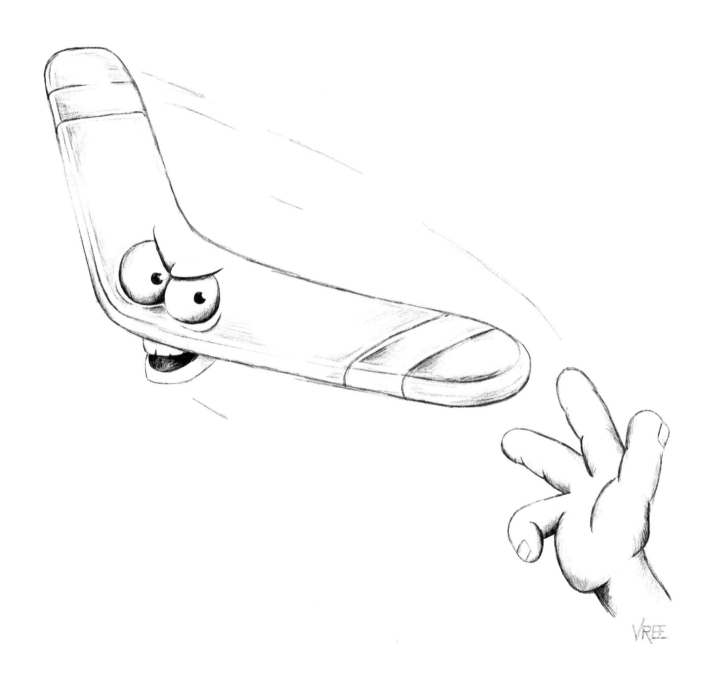

"I'll be back."

Easter Bunny

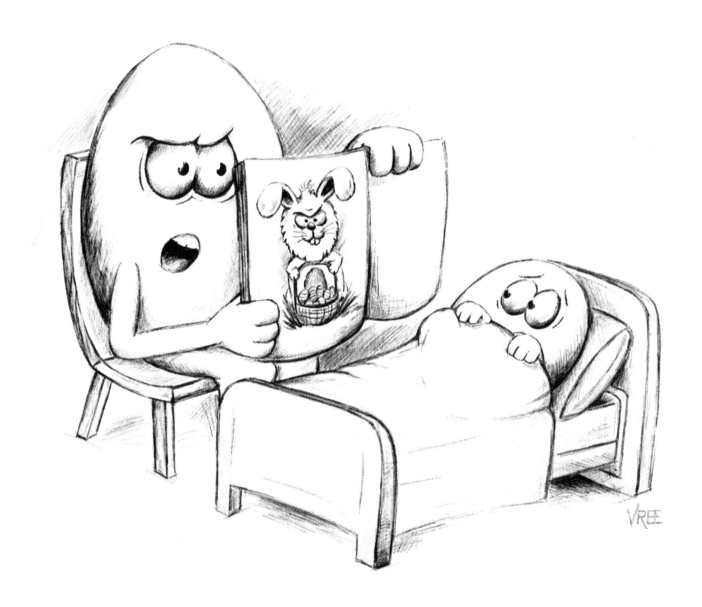

"The Bunny tossed the naughty eggs into the boiling water, dipped and dyed them, then hid them in obvious places for the humans to find ... the end."

Swine Tasting

Swine Tasting

Butter Fingers

"And from that moment on, Daryl was known only as Mr. Butter Fingers."

Occupational Hazard

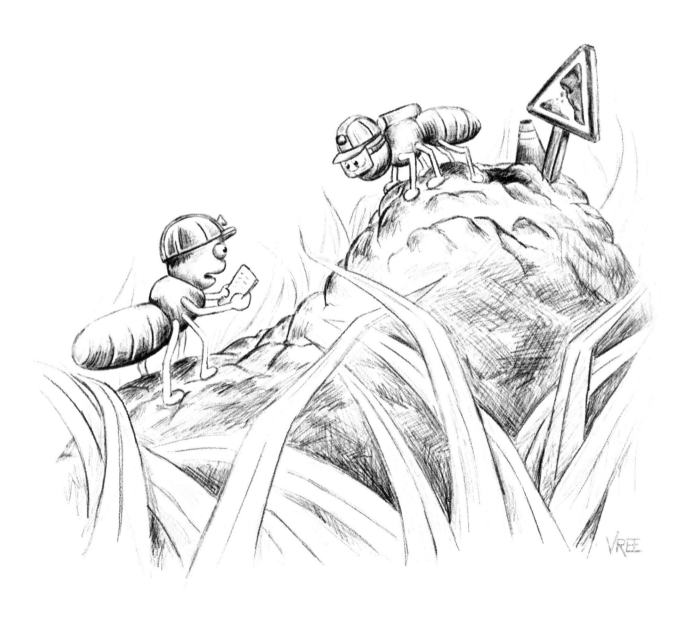

"The company requires all ants sign their medical and mandible insurance forms prior to tunneling."

Tree Pirate

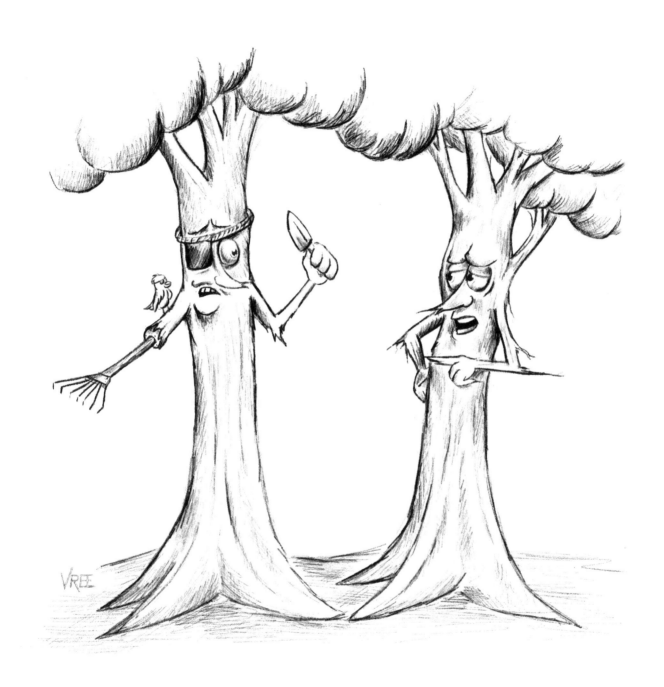

"I thought you lost that limb in a windstorm.
Your ancestors may be pirate ships, but not pirates."

Gamification

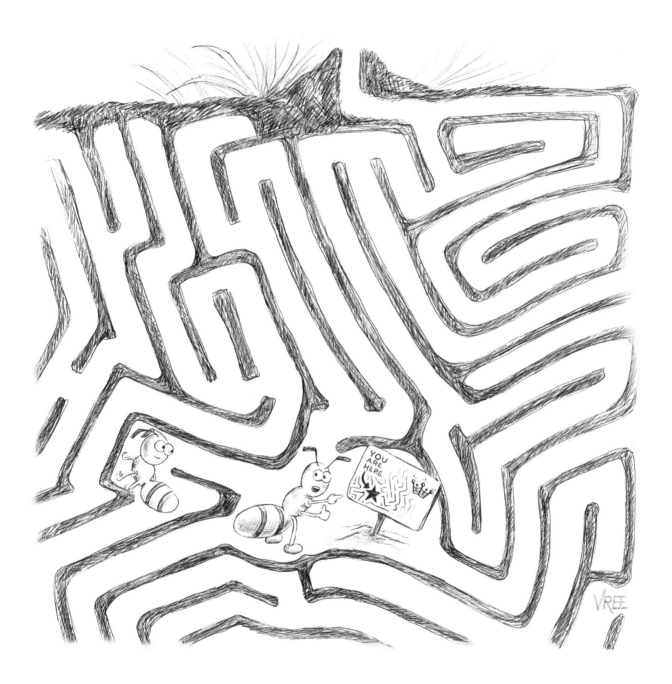

"I found another map. We're definitely closer to the boss level!"

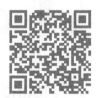

Hey Butter, Butter

"Hey butter butter, sa-wing butter!"

Wishful Thinking

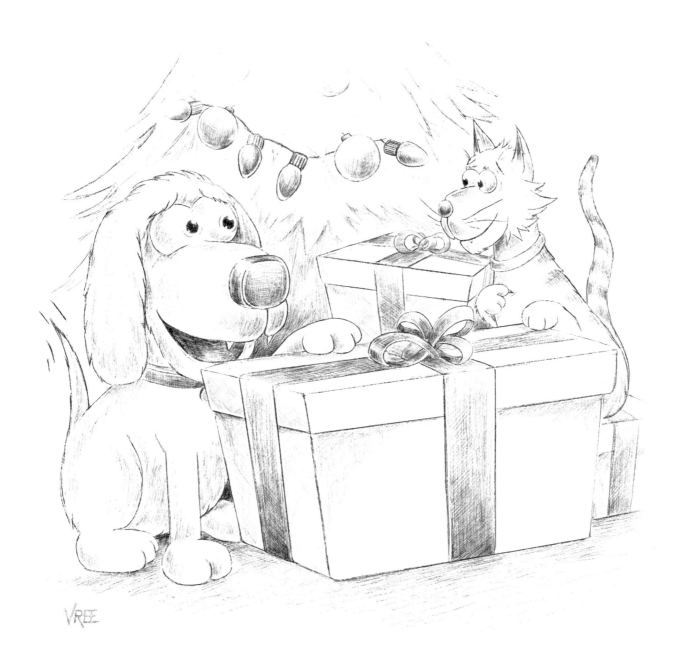

"Ah, now this gift must be for you. It smells like a
massive ball of yarn, with—*sniff sniff*—plastic buttons?"

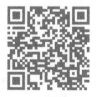

Desperasaurus

"So you're saying if I WAS the last dinosaur
on Earth ... you would marry me?"

Well Done

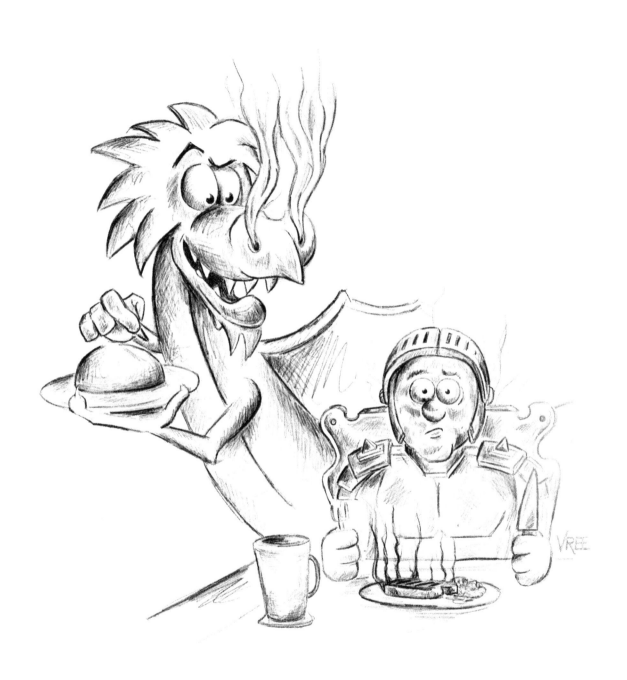

"Now THAT, sir, is well done."

Stitches

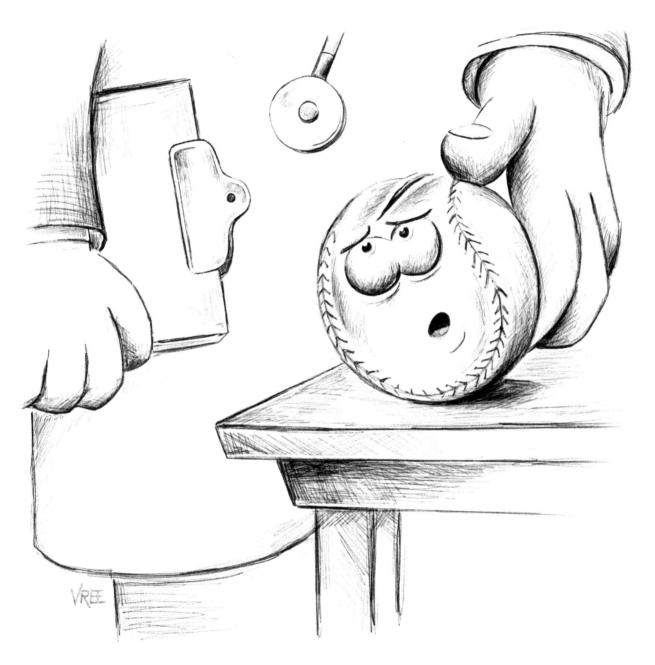

"What do you think, Doc ... do I need stitches?"

Swingers

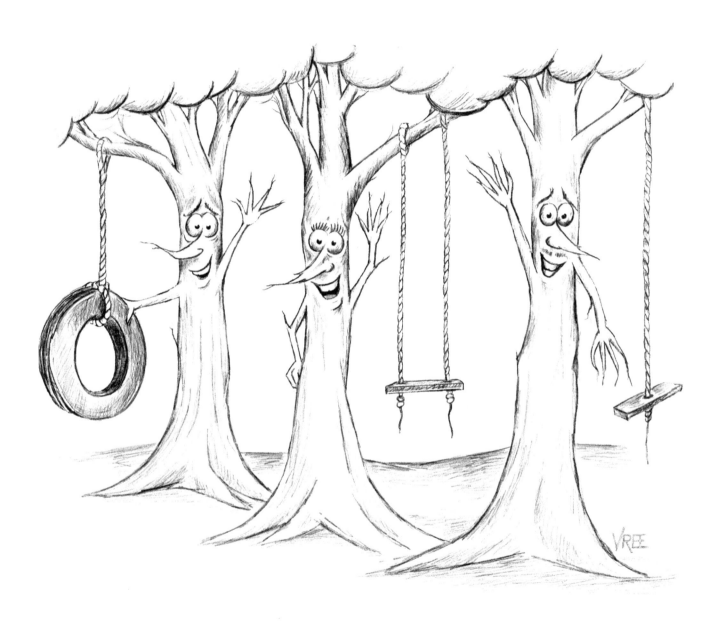

Swingers

Half Stick of Butter

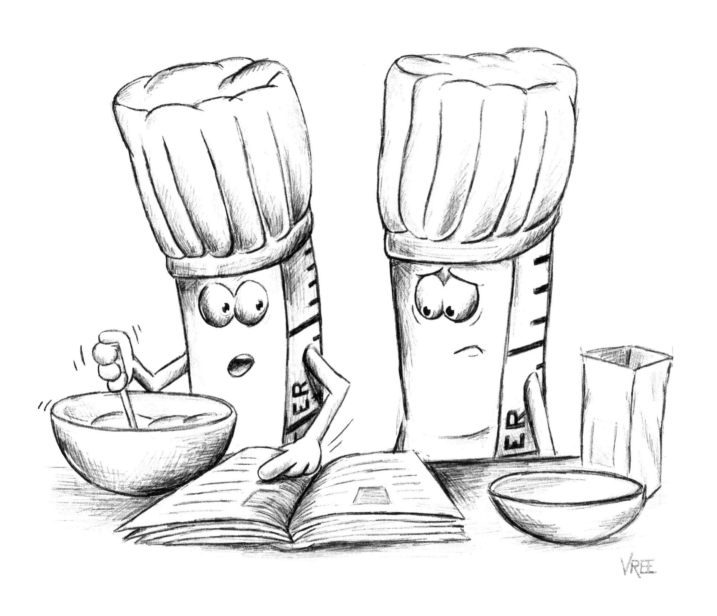

"This recipe calls for a half stick of BUTTER!"

Turf War

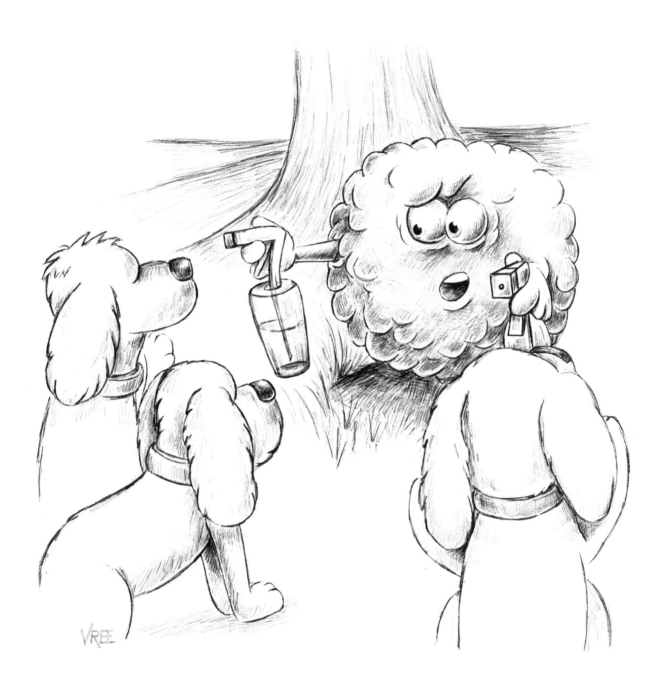

"Easy ... easy ... no one lifts a hind leg."

Life Support

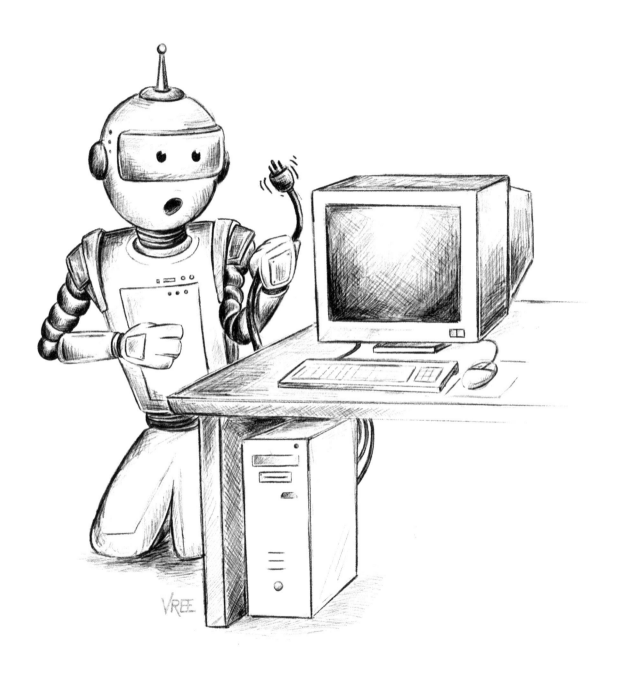

Tom inadvertently pulled Uncle Hewlett off life support.

Biggest Fan

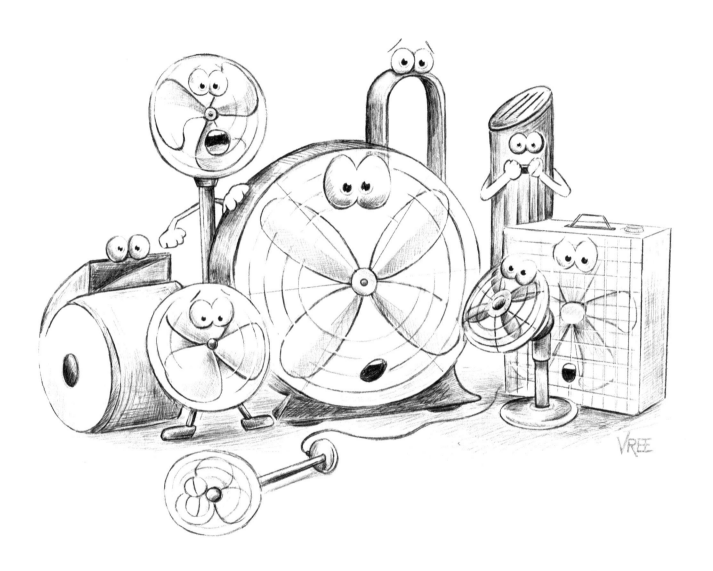

"Now which one of you here is my biggest fan?"

Clash

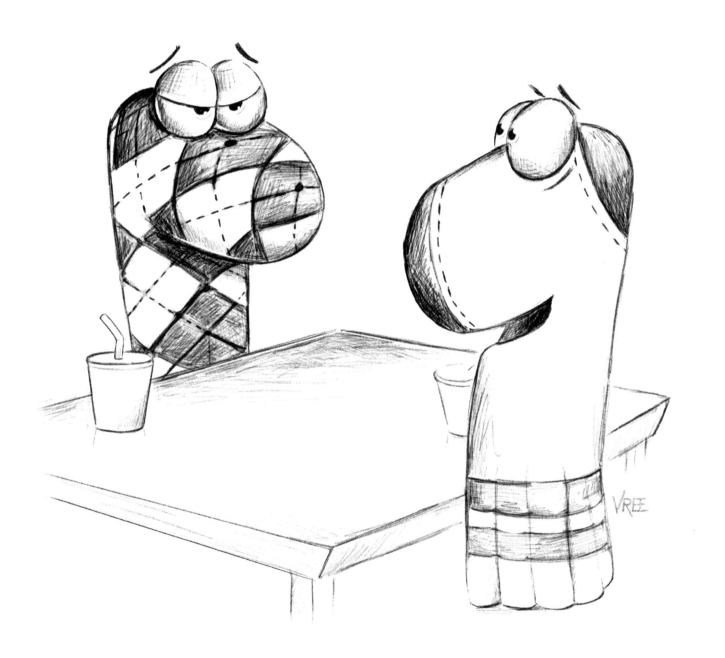

No, no … it's not you. It's just every time we go out—we clash.

Hangover

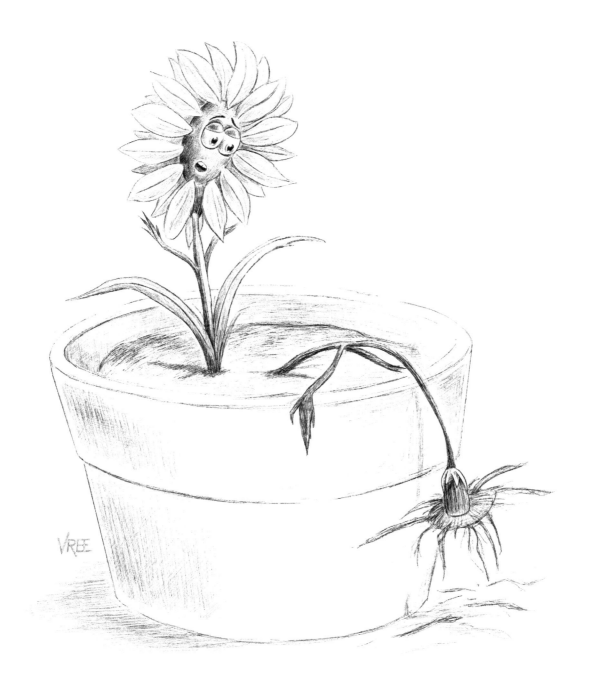

"You wouldn't be so hungover if you stay hydrated."

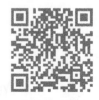

Born Lucky

Though Patrick's luck was to be expected, it was infuriating nonetheless.

The Take Down

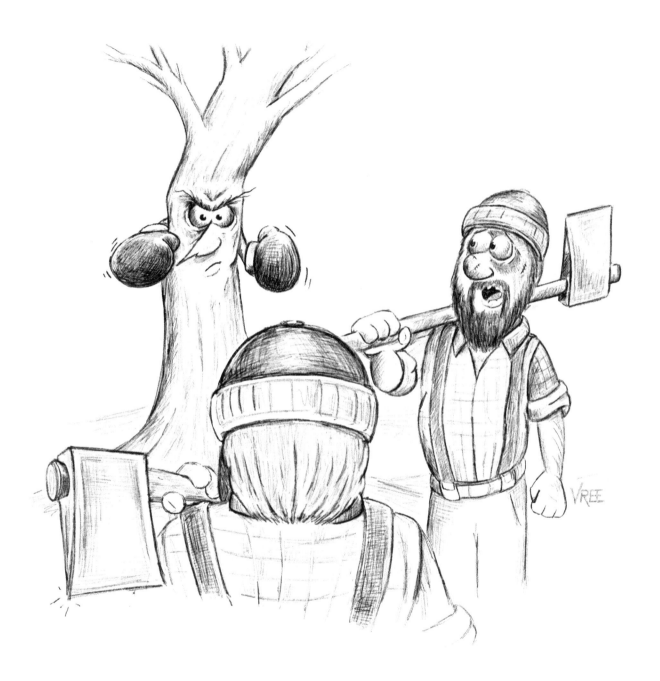

"Be careful, Paul—this one going to be tough to bring down."

Dead Lift

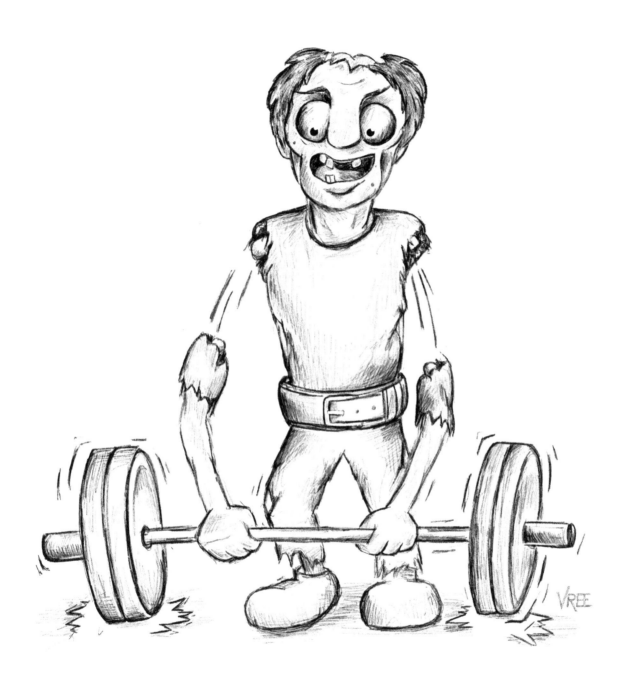

Dead Lift

Self Checkout Lane

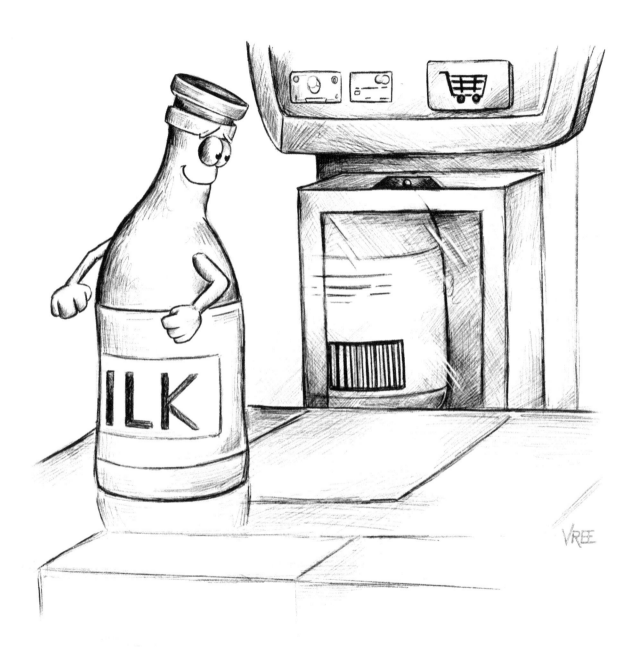

With the new and sleek carton design,
Milk got held up in the self-checkout lane.

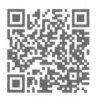

Dragon Slayer

"I don't care whose idea it was. That's my rare medieval collection—not toys."

My Jam

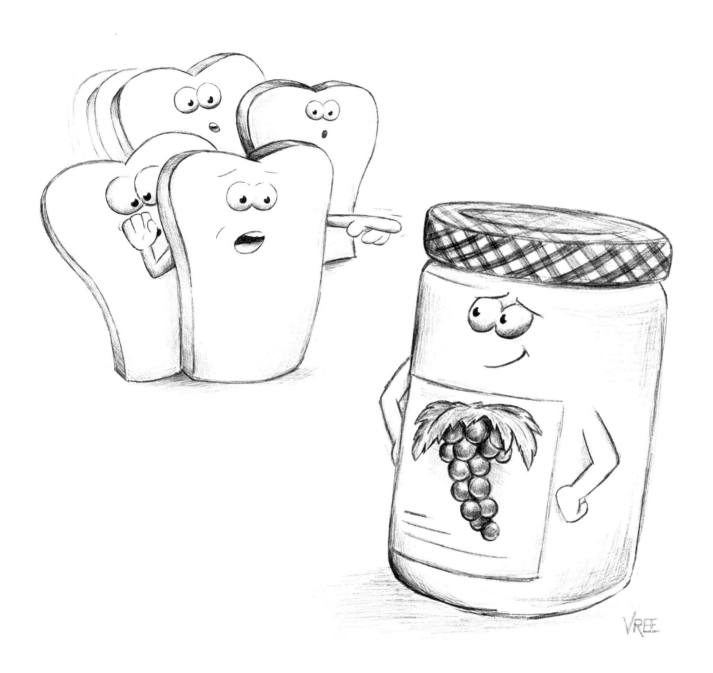

"Guys, hold up ... this is my JAM!"

Drinking Age

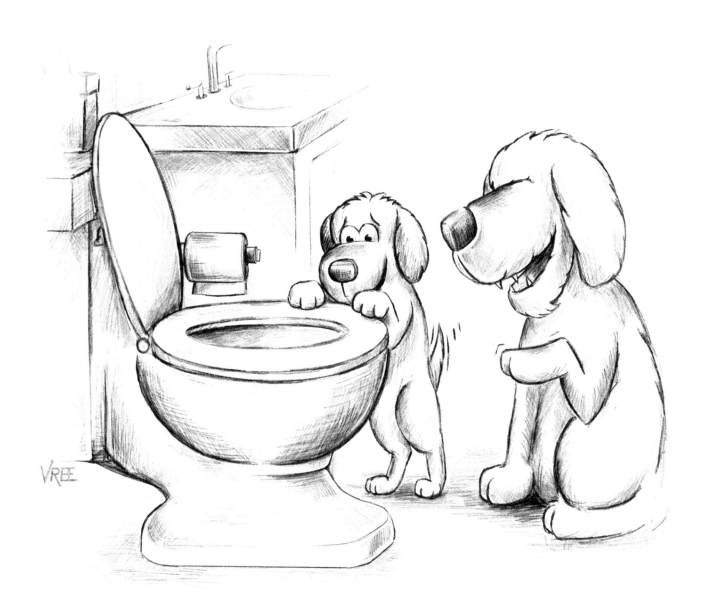

"When you're old enough, you'll get to enjoy the flavored water too!"

Haircut

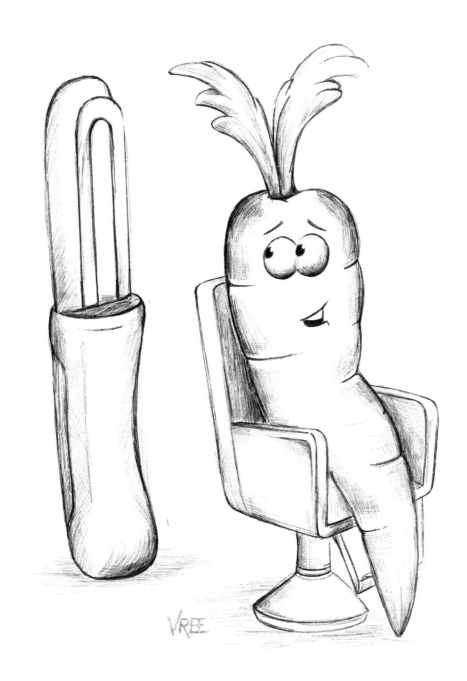

"Just a little off the sides, please."

Holiday Pay

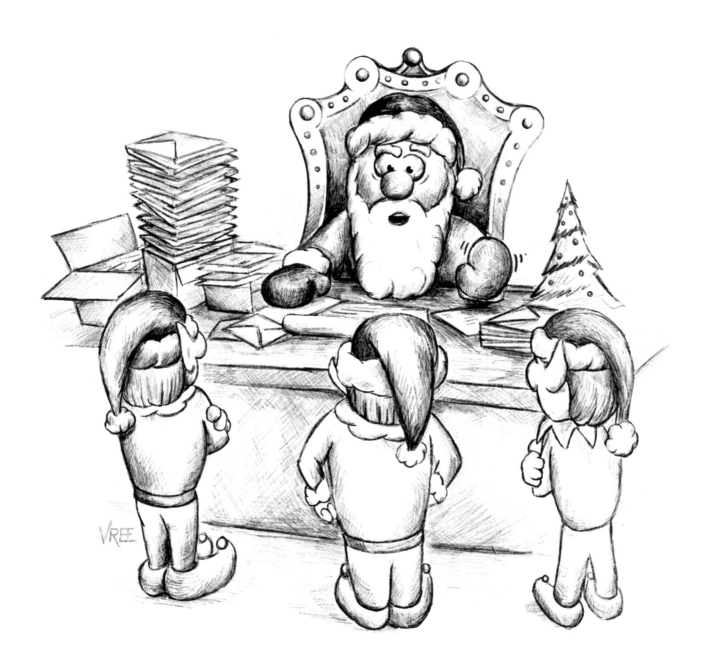

"Ho, ho, hold on a minute. I never said anything about holiday pay."

Robot Dance

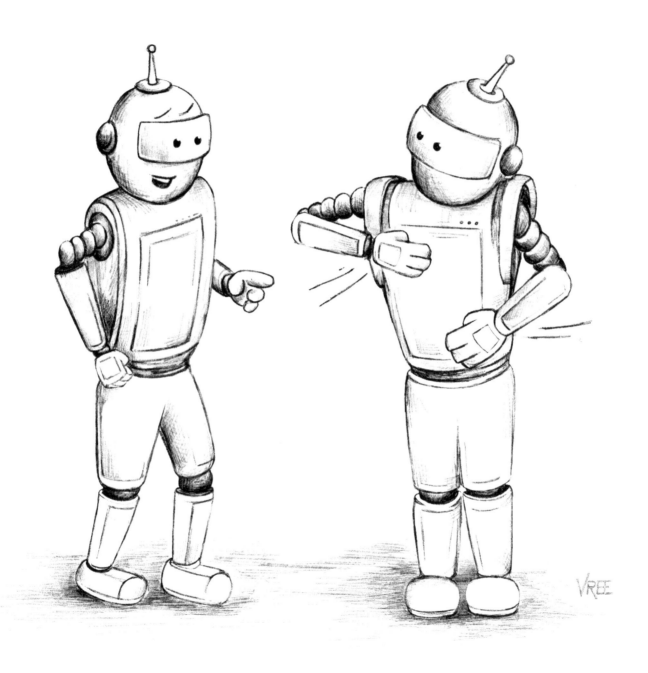

"That's my default dance move too."

Campfire

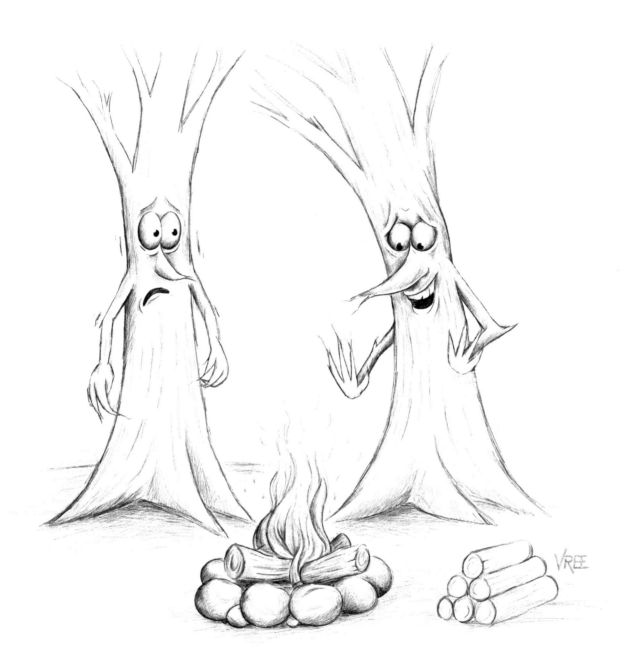

"Did I ever tell you how much I love the smell of a good ol' campfire?"

Training Day

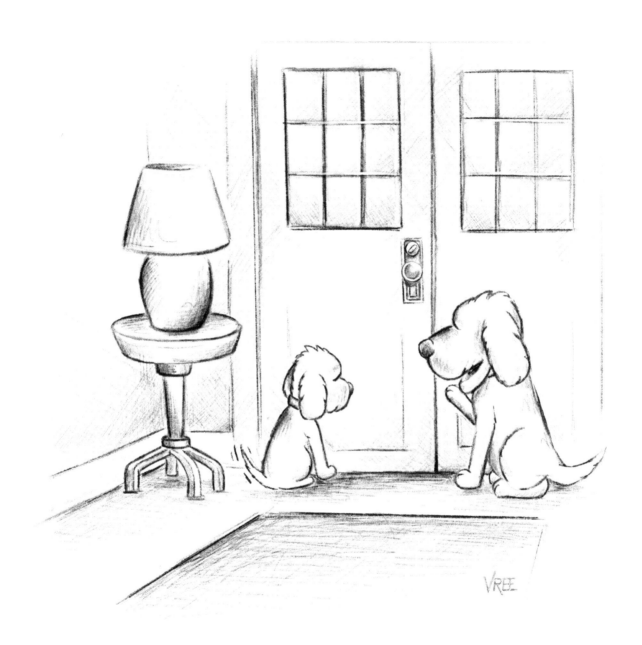

"Now, this is where the intruders will enter.
So we'll do our most prolific barking here."

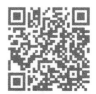

Selfie

Chip took a sudden pause for an ill-advised seflie.

Other Left

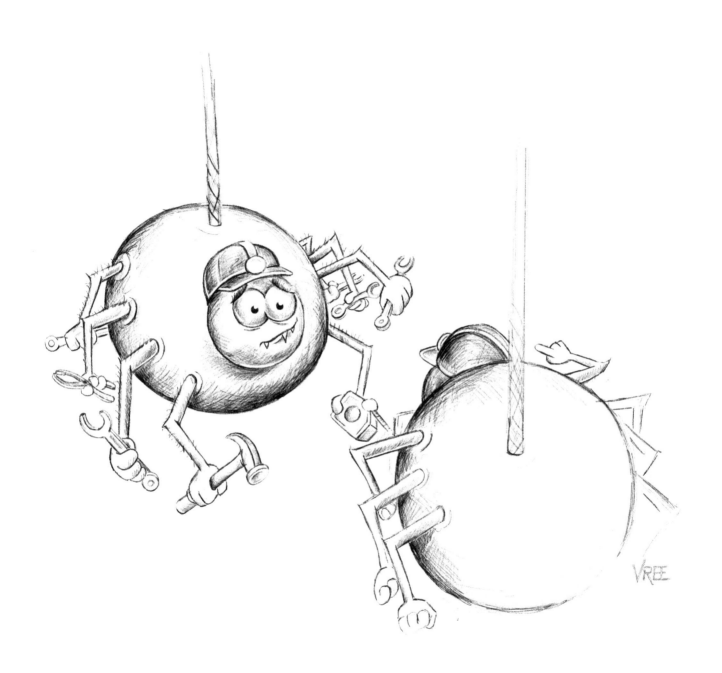

"No, no ... your other, other left"

Not a Robot

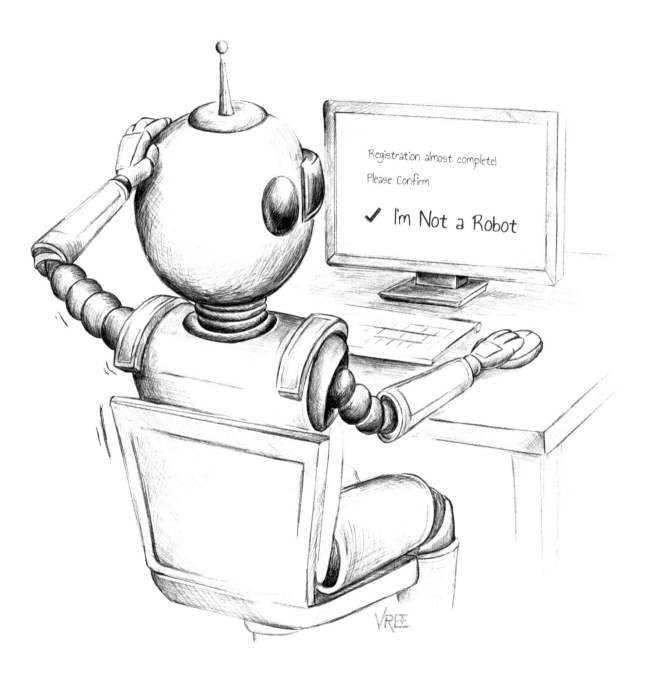

Finally, Tom could now access the endless stream of
irrelevant memes, notifications, diets, and cat videos.

Bear Scratcher

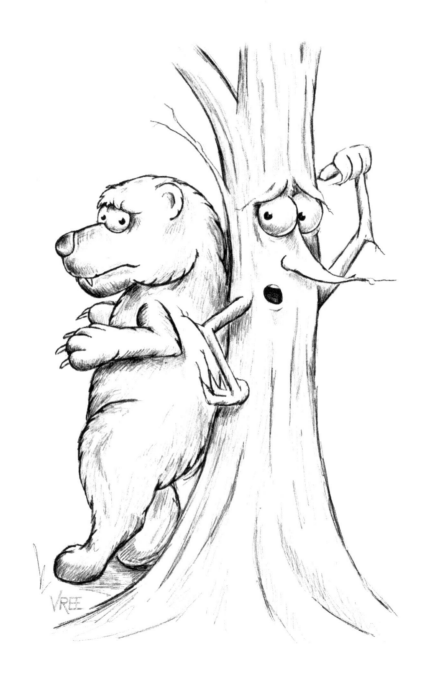

"To the left just a little more. Perfect, that's the spot.
Now really put your back into it."

Half Butter

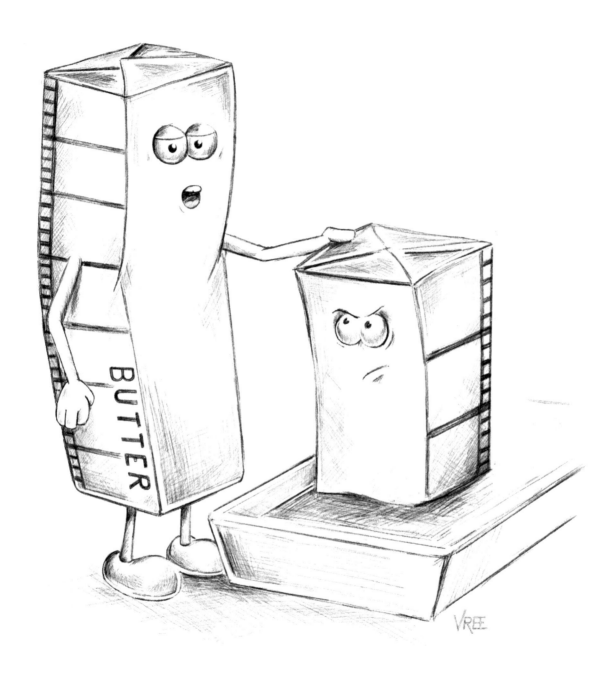

"And this is my half butter—I mean brother."

Manic Monday

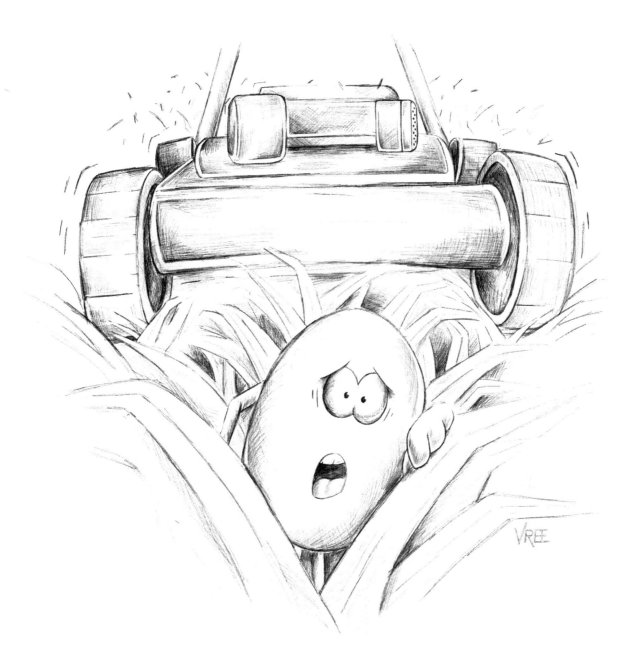

Surviving the Easter egg hunt turned out to be only half the battle.

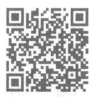

Doctor's Orders

"Where did you say you went to medical school?"

Breathe

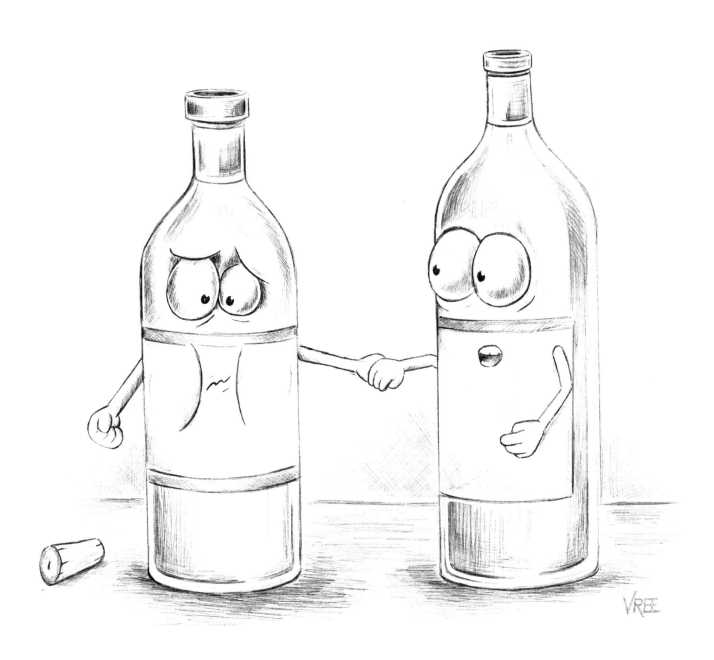

"Uh, you really need to breathe."

Air Freshener

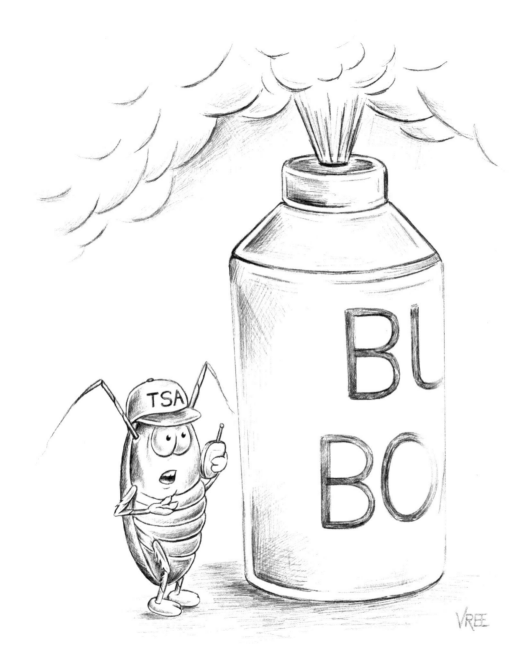

"Roger, no sign of people or pets.
Aside from this relentless air freshener, it's all clear."

Slow Jam

"This next slow jam goes out to my main squeeze ... you know who you are."

Spots

"Oh, wow this tie has spots! I love spots."

This Tall

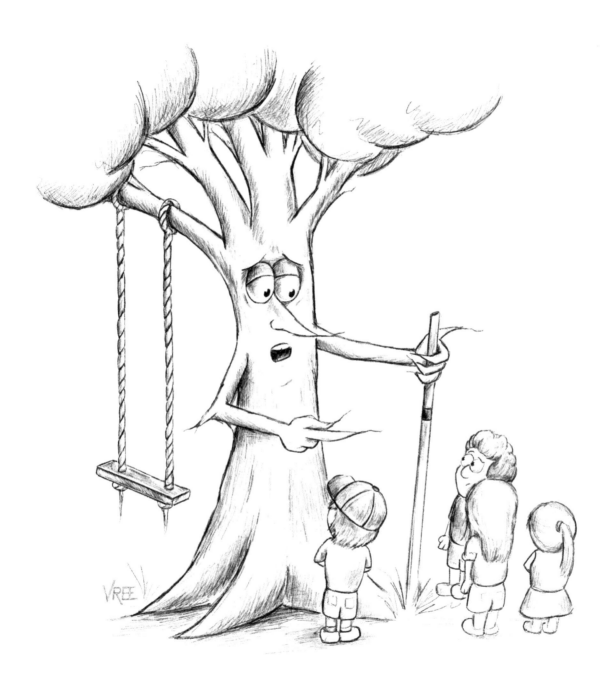

"Sorry—you must be at least this tall to ride the swing."

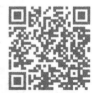

Art Show

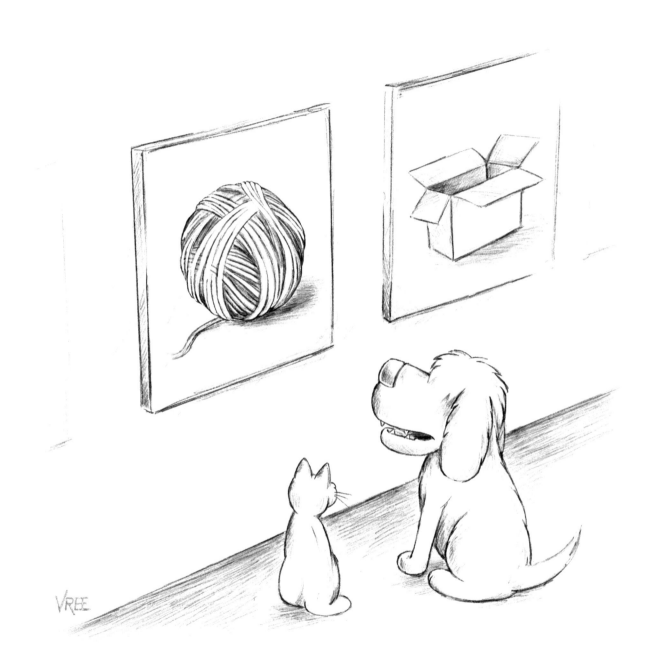

"No ... no I don't think this piece is provocative."

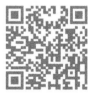

Extreme Doubles

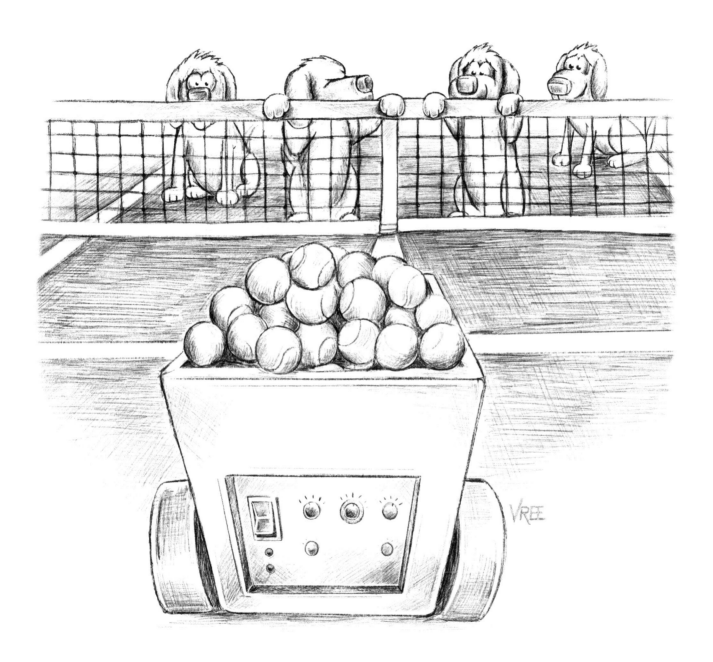

Extreme Doubles

Sunscreen

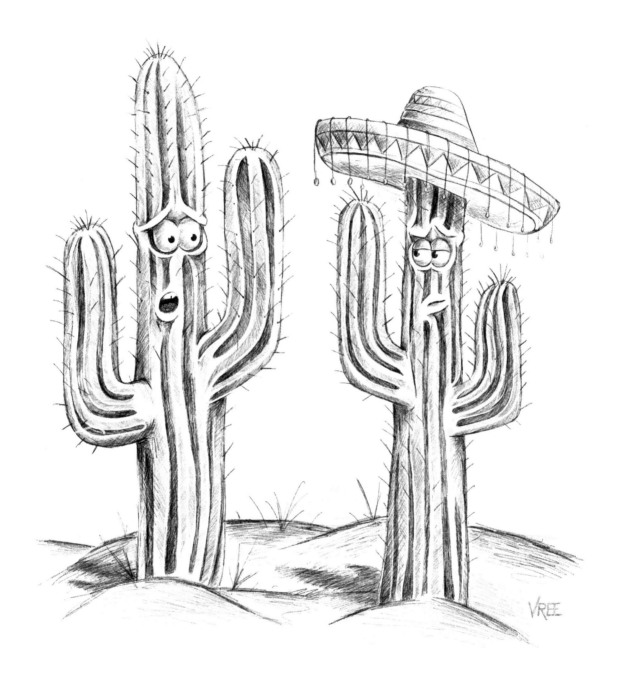

"You really think I'm getting too much sun?"

Costume Party

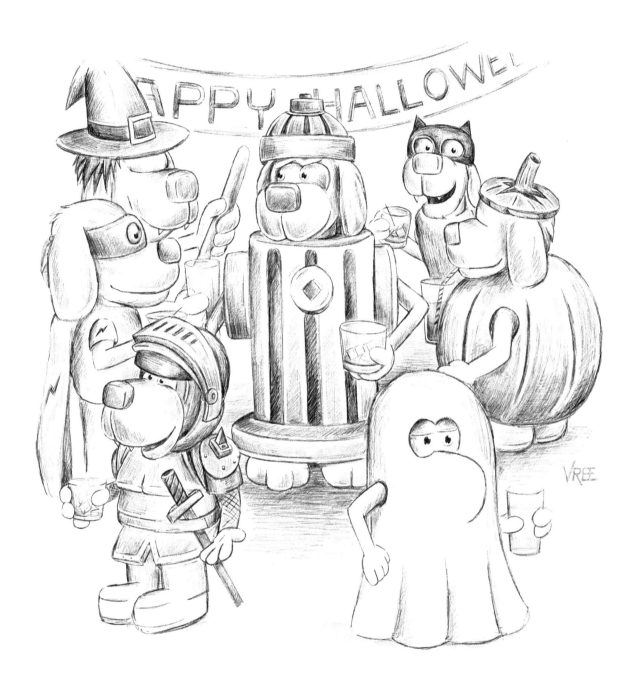

Unfortunately for Sprinkles, a few drinks in
and suddenly his costume was a big hit.

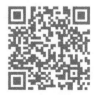

Hawk Eyes

His friends call him Hawk Eyes.

Parental Controls

After a prolonged debate over cleaning up toys,
Tom finally implemented parental control.

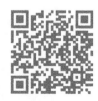

Holiday Cheer

"Hey, folks, I know it's not even Thanksgiving yet, but this is our first Christmas. Let's give this barn some holiday cheer ... who's with me?"

Christmas Lights

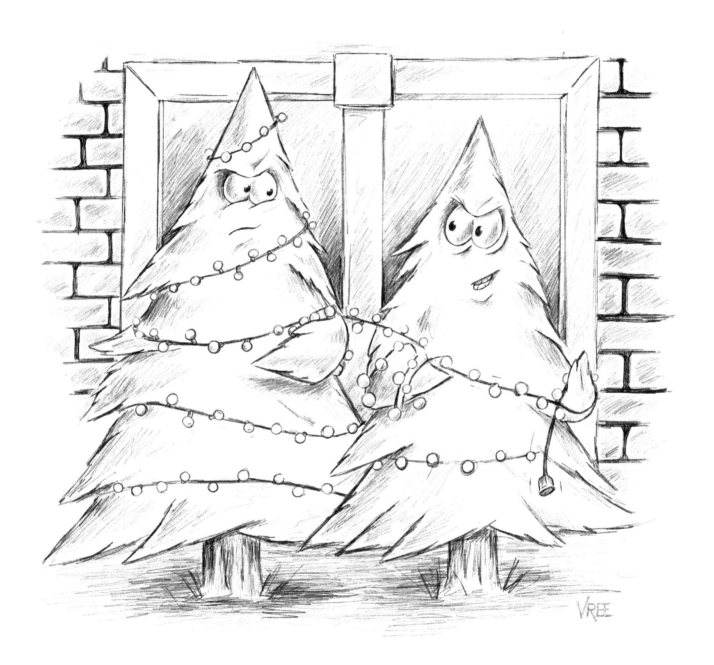

You can never have too many Christmas lights.

Santa Suit

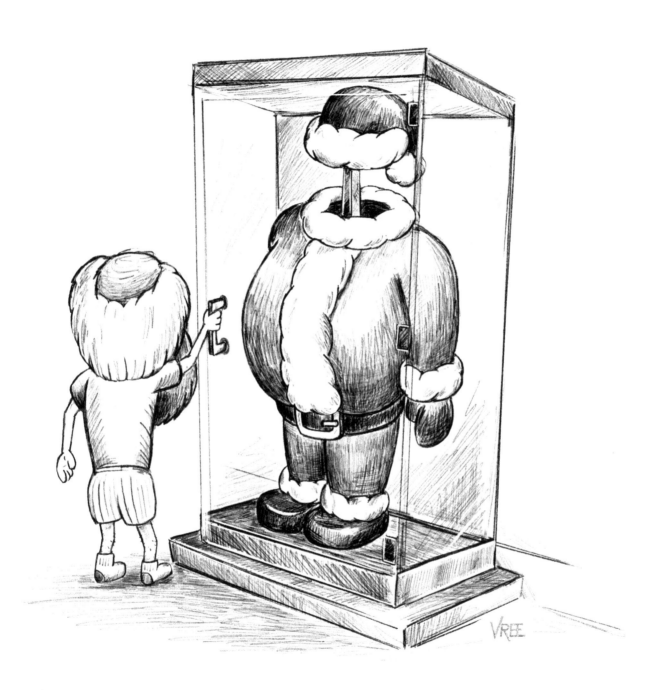

To the Santa Suit

Heated Benches

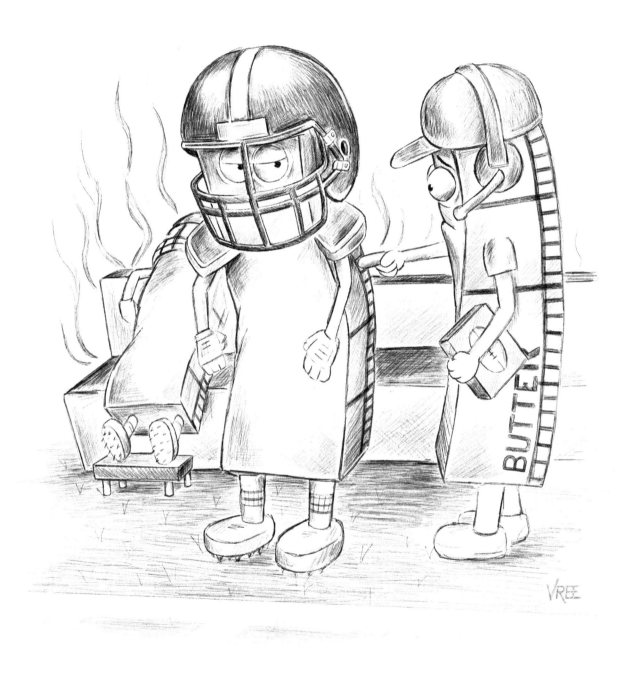

The addition of the heated benches had indeed softened his players.

The Odd Couple

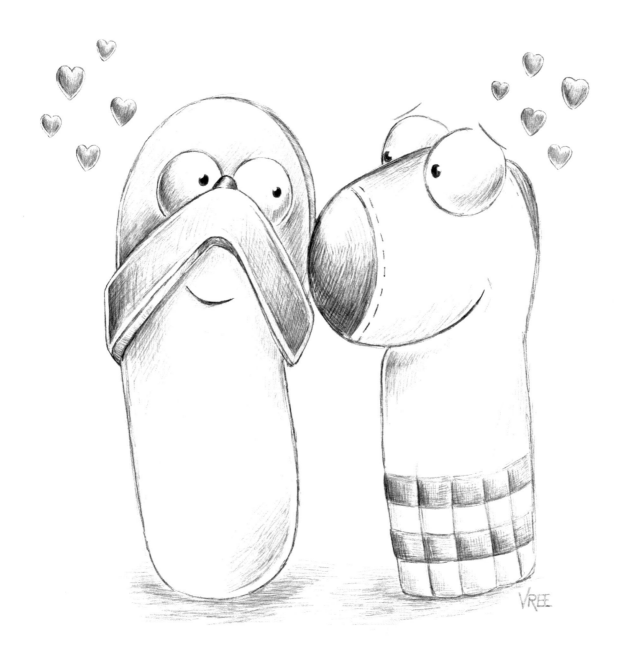

He loved the beach life and she couldn't stand the water,
yet somehow their love endured.

Walking Dead

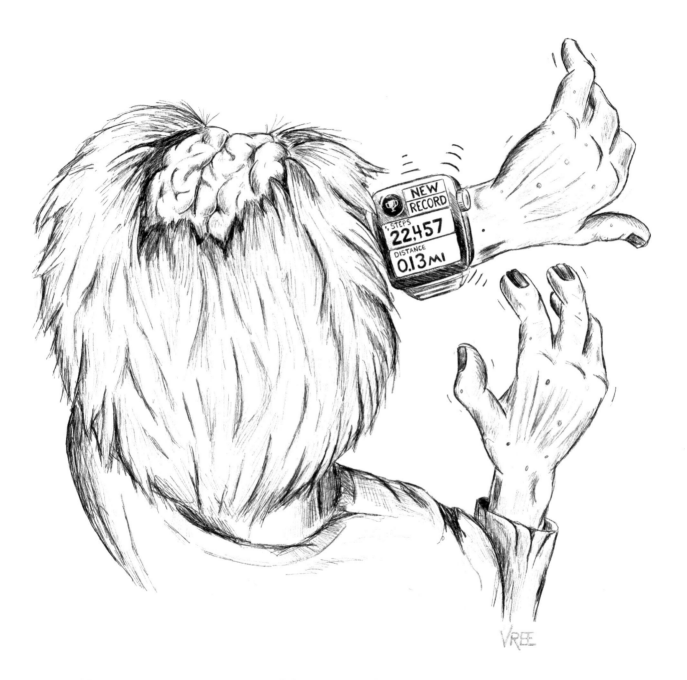

"New personal record! .03 miles in 22,457 steps. Keep moving!"

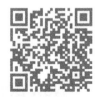

Turkey Day

"Hey, it's not the most glamorous job, but it's a living."

Good Cop Bad Cop

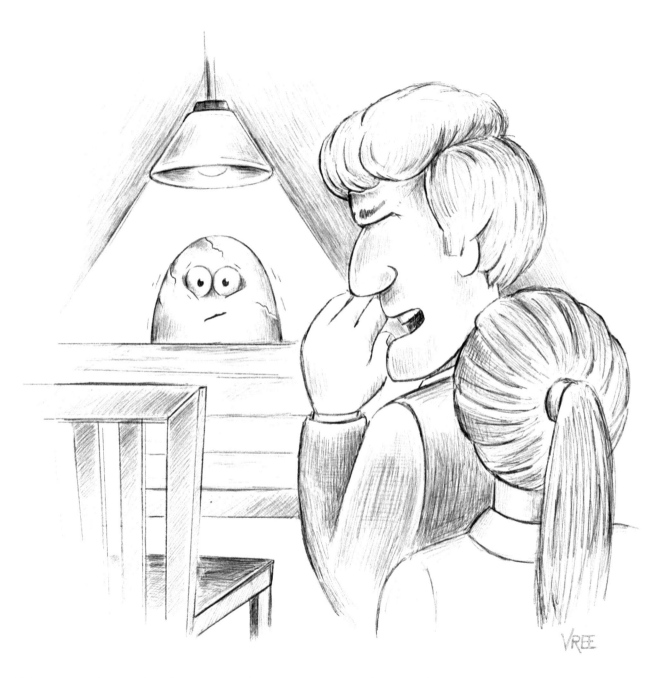

"This good cop, bad cop routine appears to be working. He is starting to crack."

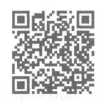

Spring is in the Air

Spring is in the air, seat 22F

Spotlight

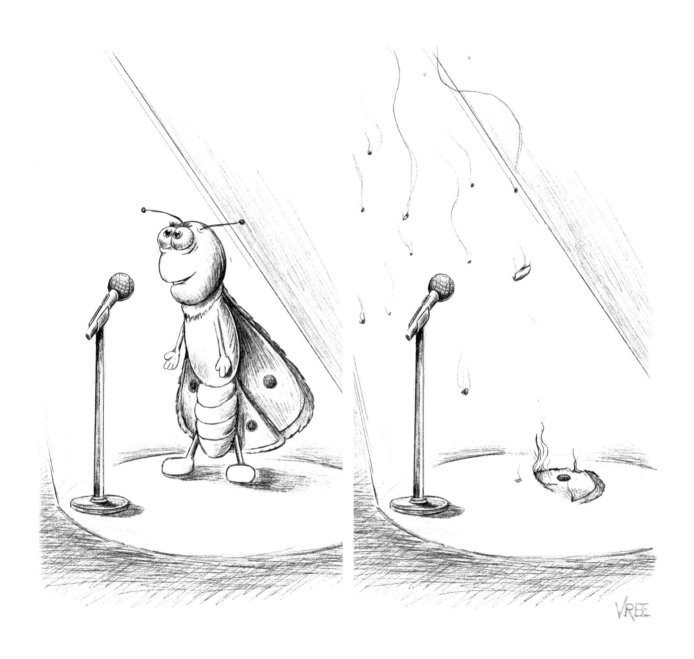

Molly loved the spotlight ... a little too much.

Pat of Butter

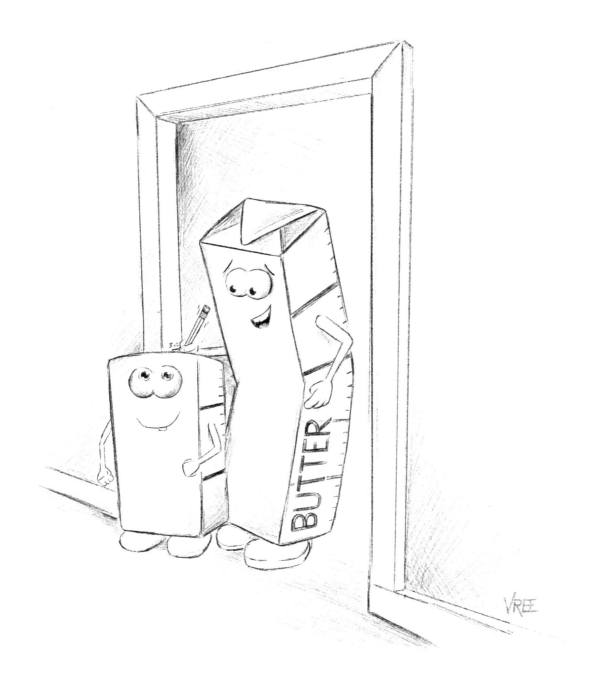

"Wow, Pat, you've grown a whole half table spoon!"

Shoe Selection

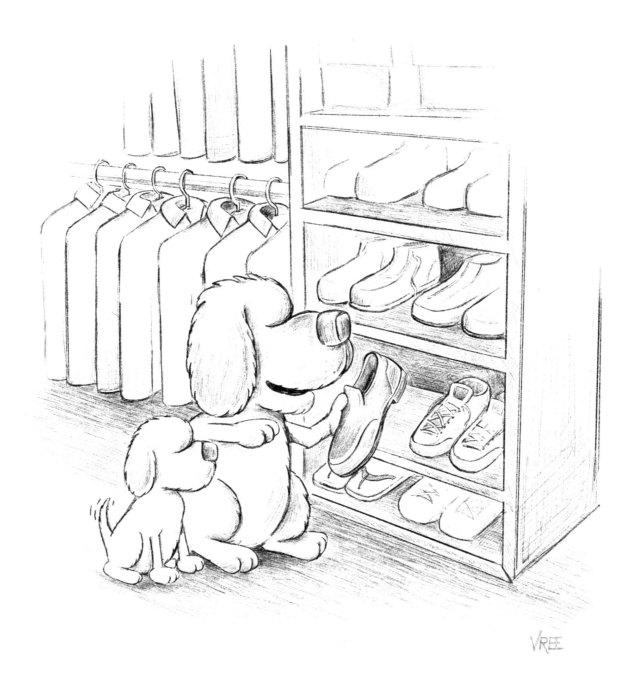

"Now here's a vintage Italian with bold, earthy tannins.
We'll save this one for a special occasion."

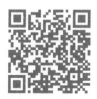

Dead Wrong

"Again, you are dead wrong Kevin. The correct answer is,
What is the Great Pyramid of Giza."

Sleep Deprived

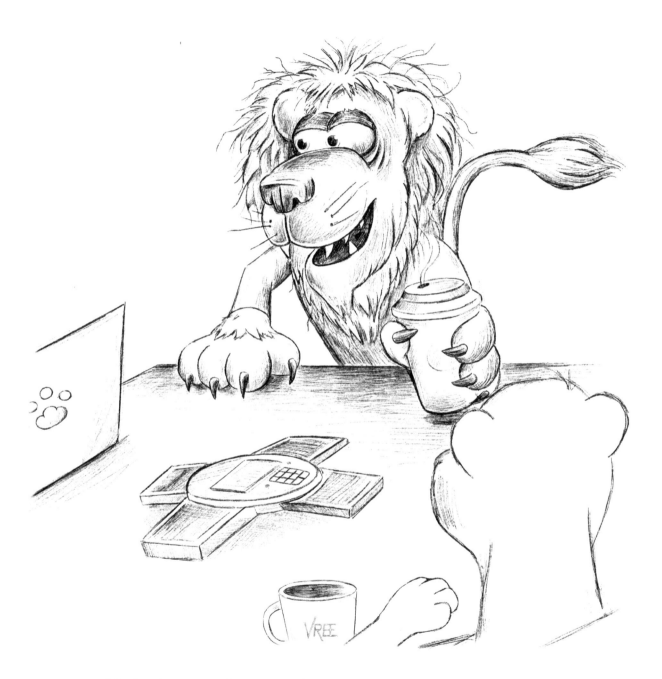

"To be honest, I'm not a big fan of these early meetings.
Or the daytime nap restrictions."

Uncle Spruce

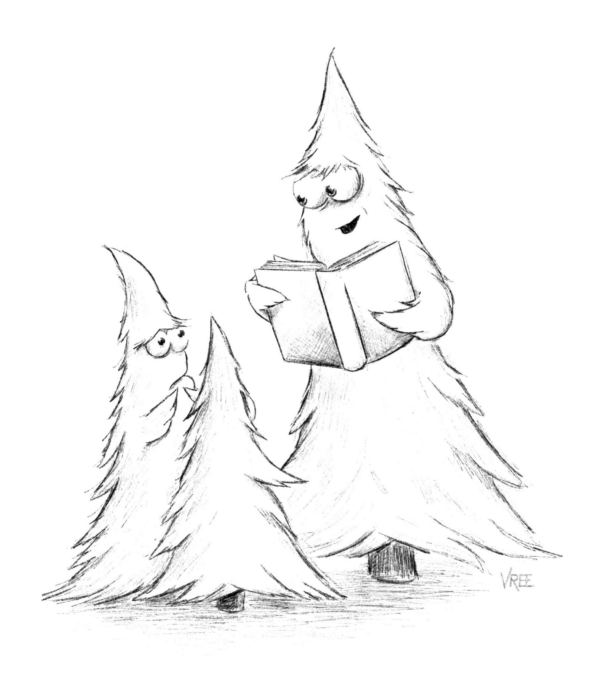

"Not exactly, kids. Uncle Spruce didn't write the book.
He actually *is* the book. On the bright side, it's an excellent book."

Bodybuilder

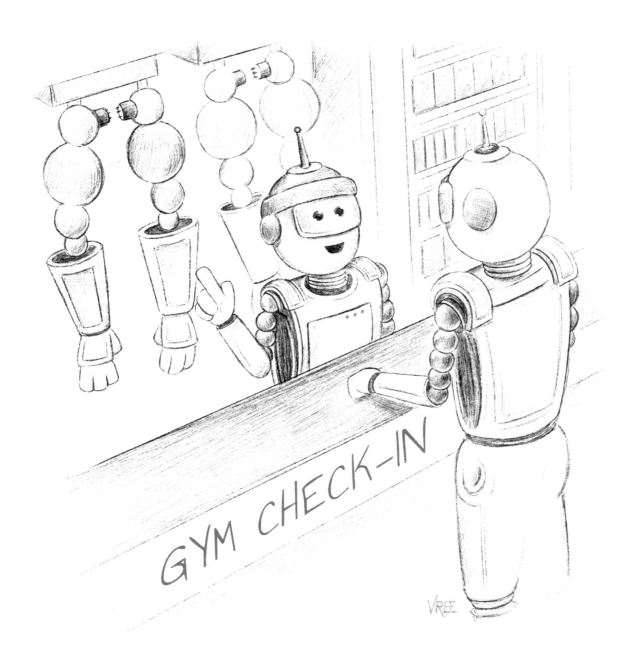

"Welcome back, Tom. Want to start off with the big arms today?"

Peanut Allergy

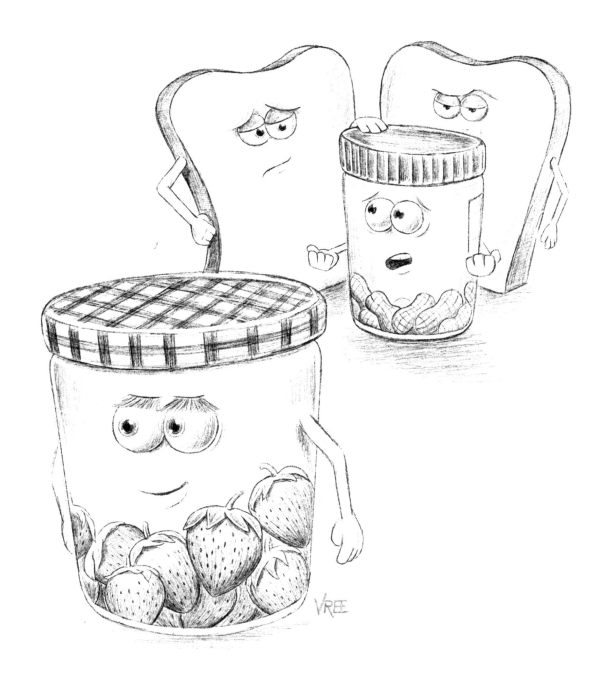

"Uh ... I don't know, guys. I mean ... what if she has a peanut allergy?"

Hot Stuff

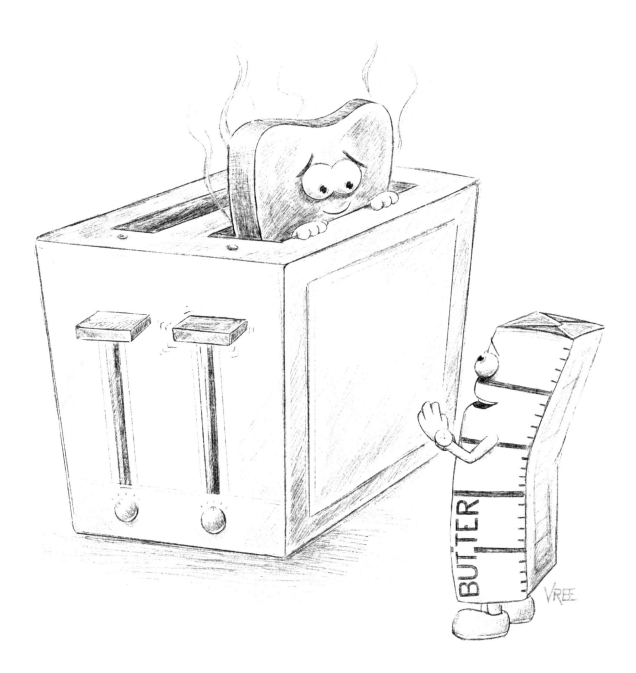

"Well hello, hot stuff. Looks like I'm just in time!"

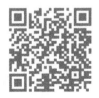

Clammy Hands

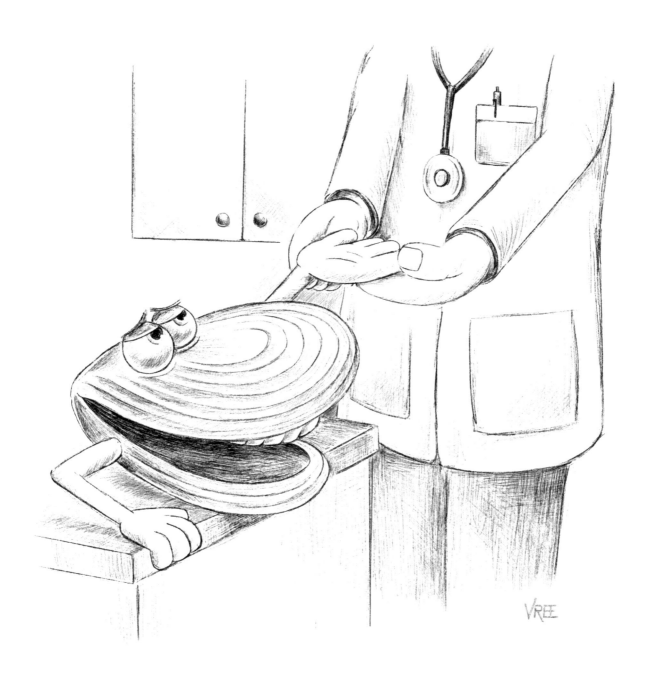

"Yes, Doc, I know. My hands are always clammy. Now can we get back to why my jaw is so stiff?"

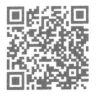

Shady

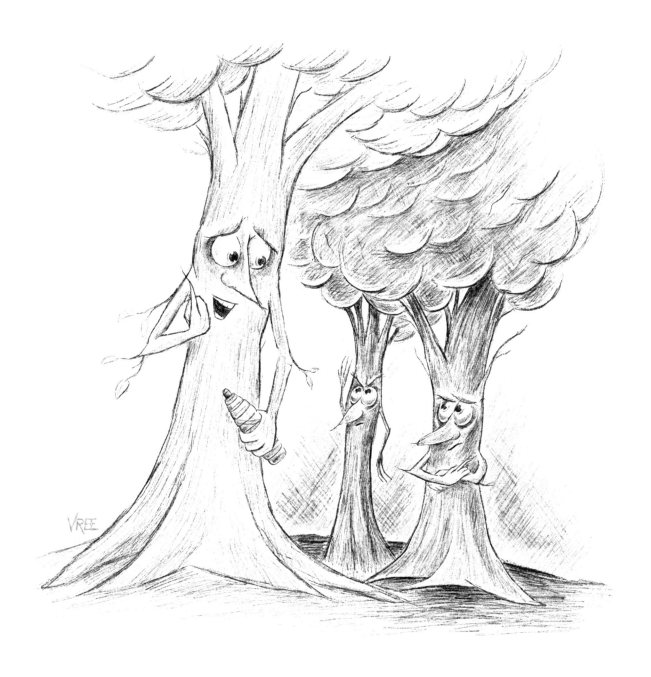

"I hate to throw so much shade on you guys.
It's been a very, VERY good growth year for me."

Grounded

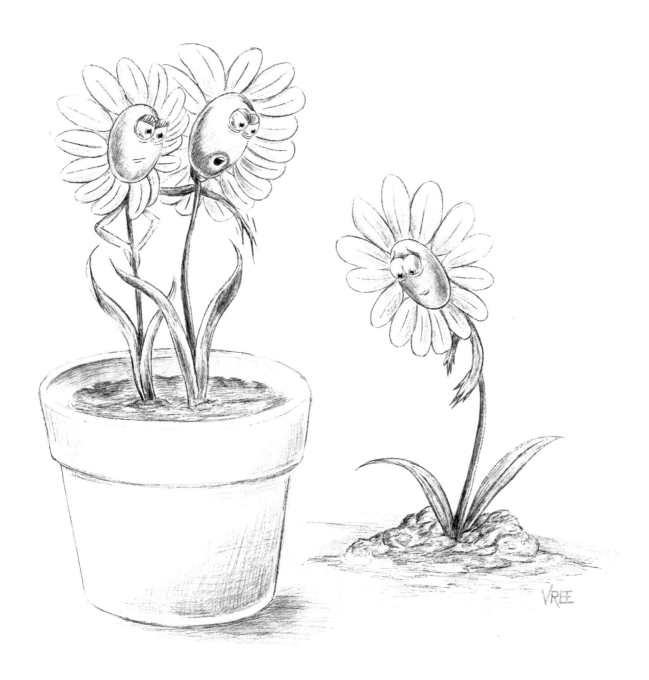

"Oh—you're grounded for at least a week. And quite frankly, your Mom and I think this will be good for you!"

Conversation

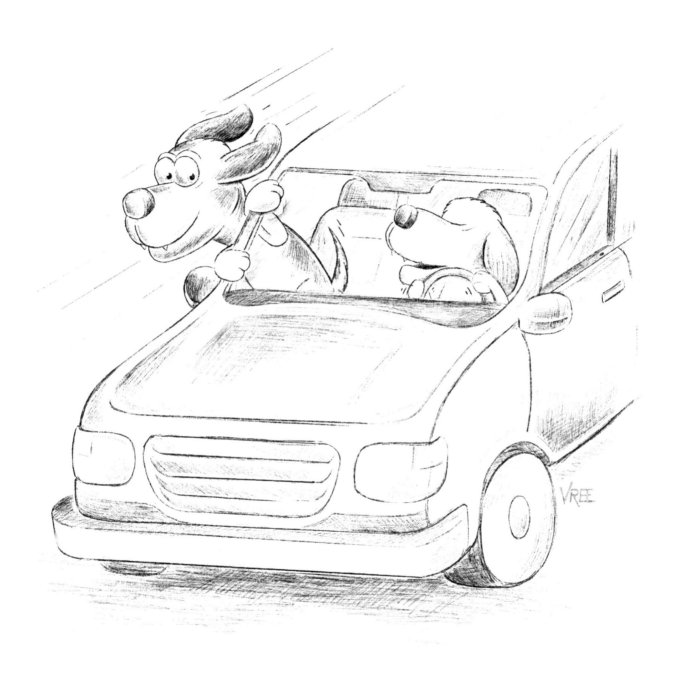

"You know, it's hard to have a serious conversation when you keep doing that."

The King

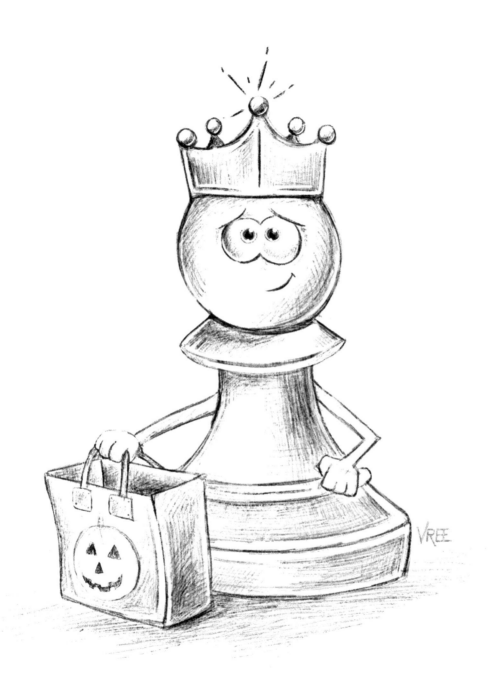

King for a day.

All Ears

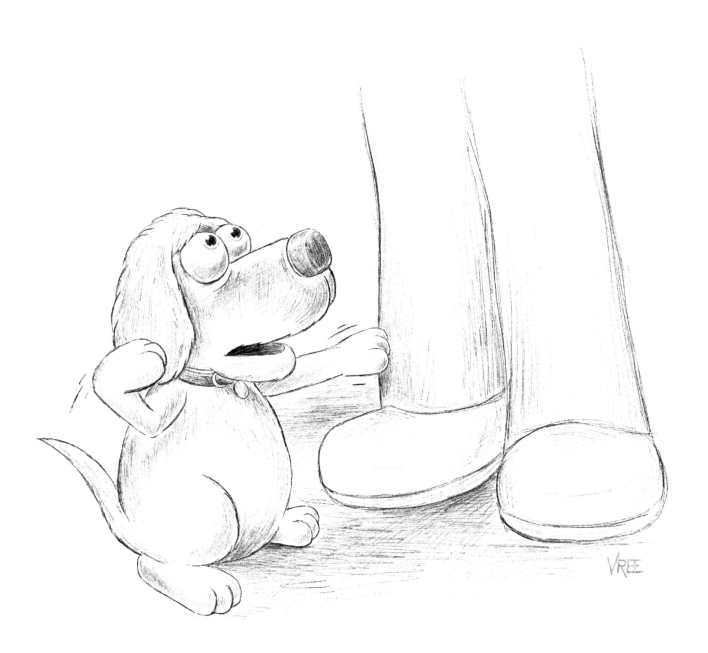

"Hey, you know I'm all ears."

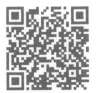

Fake Tree

"Oh yeah, you're absolutely right ... the smile is a dead giveaway. It's definitely a fake tree."

Real Tree

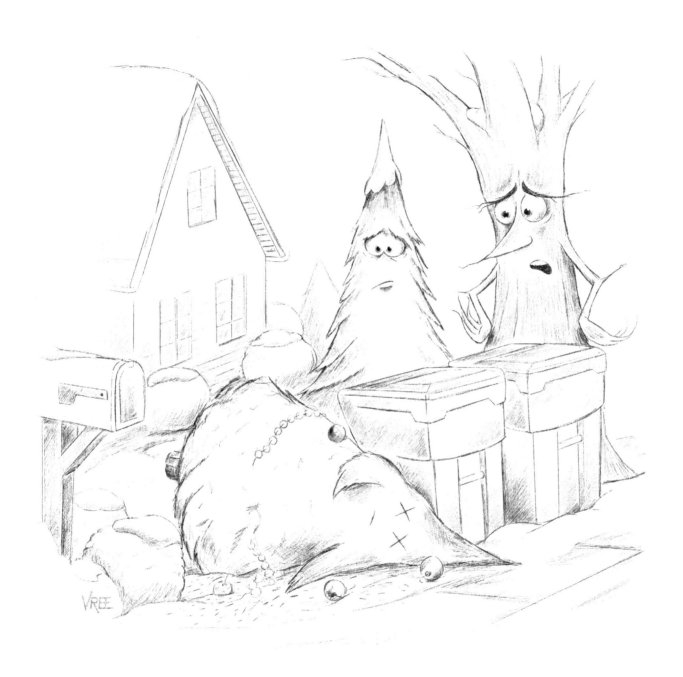

"Well, now that is very unfortunate. He was literally just so festive."

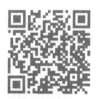

Revolving Door

Game Night

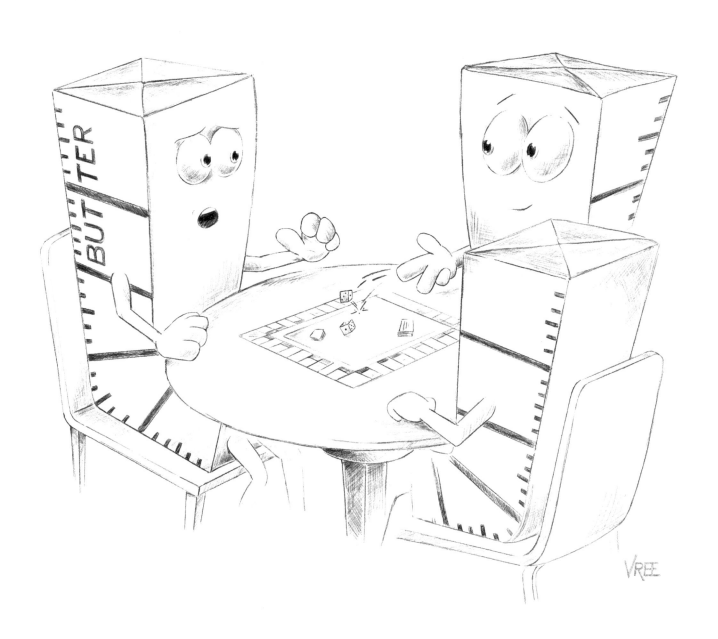

"Whoa ... wait a minute. Is it my churn or yours?"

Eraser

"See ... it's like it never happened."

I grew up in Greenville, Kentucky, a small town where life was slightly unusual. My brothers and I took shortcuts through the woods. We played with our neighbors outside. And due to a lack of strangers, we never locked our doors. Luckily, I left for college in Cincinnati, where I was safe from these unusual things. By the time I graduated with my trusty Fine Arts degree, the internet was coming of age. In five years, I went from using pencils and paintbrushes, to using a mouse with Photoshop, to animating, programming, and co-founding two companies. I had no idea what I was doing, but neither did anyone else. It was the perfect time to fake being an expert.

I've designed and built apps for businesses both large and small, and even for a few famous folks along the way. So far I've been part of six start-ups, all with pretty crazy ideas and even crazier outcomes. I've learned a lot about people, partnerships, life, and how important it is to keep a good sense of humor. Art and storytelling has, and always will be, an important part of my life.

My family and I recently moved from Cincinnati to Charlotte, North Carolina. I miss our family and friends there, but I don't miss the cold weather. My wife and two kids inspire me to enjoy life and laugh. I'm a big fan of irony and logical arguments. And while I'm totally addicted to coffee and tennis, I refuse to combine the two.

CPSIA information can be obtained
at www.ICGtesting.com
Printed in the USA
BVHW051931150921
616811BV00006B/390